THEN & NOW

LAKE PLACID

To Bill and Jo,
I hope you find some
interesting facts about Lake
Placid within this book — and
in the future get a chance to
visit these sites in person.
All my love and prayers —
Laura.

Opposite: The Beede family poses for the photographer in the late 1880s in front of their home on the Old Military Road. The house, supposedly, had been the Flanders house, the house which famed abolitionist John Brown rented when he came to North Elba (Lake Placid) in 1849.

THEN & NOW

LAKE PLACID

Laura Russell Viscome

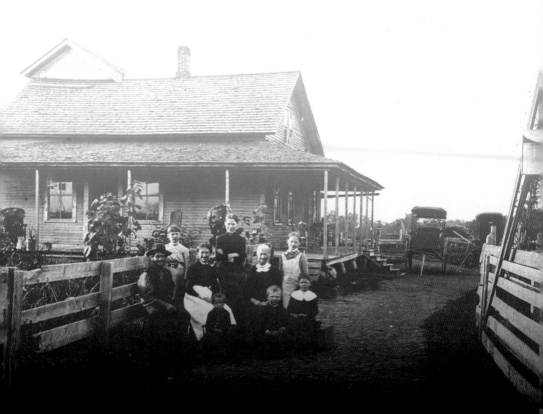

To those residents of North Elba and Lake Placid, who for over 200 years have faced with cheerful perseverance both hardship and ever changing weather to live amid these magnificently beautiful Adirondack high peaks, and to those who, it is hoped, will in the future do the same, I dedicate this book. This includes my children George, Laura Jean and Mark Clark, John and Janet and my grandchildren Warren and Samantha. To my sister Janet Daly, who has supported me through this project, go my love and sincere thanks.

Copyright © 2008 by Laura Russell Viscome
ISBN 978-0-7385-5672-7

Library of Congress control number: 2007943797

Published by Arcadia Publishing
Charleston SC, Chicago IL, Portsmouth NH, San Francisco CA

Printed in the United States of America

For all general information contact Arcadia Publishing at:
Telephone 843-853-2070
Fax 843-853-0044
E-mail sales@arcadiapublishing.com
For customer service and orders:
Toll-Free 1-888-313-2665

Visit us on the Internet at www.arcadiapublishing.com

On the front cover: See Page 63. (Vintage image courtesy of the Lake Placid-North Elba Historical Society; contemporary image author's collection.)

On the back cover: See Page 86. (Courtesy of the Lake Placid-North Elba Historical Society.)

CONTENTS

Laura Viscome

I hope you
enjoy the
book and are
familiar with
some of the
places.

Love
Laura

ACKNOWLEDGMENTS

Being an average photographer and a person who has always been interested in Lake Placid's interesting and unique history, I enjoyed every minute I spent working on this book. When asked if I would do it, I jumped at the opportunity as a way of benefiting the Lake Placid-North Elba Historical Society, which will realize all the author's portion of the profits. As a longtime member of the Lake Placid-North Elba Historical Society, the board of trustees graciously gave me access to the society's archives. More than 85 percent of all the historical (or "then") photographs are from that collection. For their support and confidence, I am deeply grateful. The remaining historical photographs are from persons whom I have acknowledged below and noted the pages on which their photographs appear. The contemporary (or "now") photographs are mine except those noted below.

The generosity of time by dozens of persons in the community was essential in the creation of this book. My thanks go to Patty Perez, head librarian of the Lake Placid Public Library, who gave me ready access to the irreplaceable collection of historical articles and photographs of late town; village historian, Mary Landon MacKenzie; Ken Torrance for historical information and the family farmhouse photograph (page 11); Chris and Nancy Beatty who let me delve through their extensive postcard collection and select cards from it (pages 61 and 81); Cerce Belden of New Russia for permission to use a photograph from her historical note cards (page 88); Bob Hammond of the Olympic Regional Development Authority, who provided the Conference Center's architectural sketch (page 95); the 1932 and 1980 Olympic Museum for the photograph of the 1980 Winter Olympics Opening Ceremony (page 89); Richard Aldridge of Northwood School (both on page 56) and Jim Million of the Adirondack Mountain Club (page 23), who both provided photographs of their respective organizations; the Loren Torrance family for providing the Torrance Dairy photograph (page 75); and the Lake Placid Center for the Arts (page 52).

A most important part of the book, the text accompanying the photographs required extensive research in newspapers, Mary MacKenzie's writings, magazines, and quite often from active community members and retirees whose memories are very sharp. I am indebted to Beverley Pratt Reid, our present town historian, for her willingness to proofread the thousands of words associated with the photographs.

If I have forgotten anyone, I hope I will be forgiven.

INTRODUCTION

A Vermont farmer, wounded at the battle of Bunker Hill, discovered the virginal beauty of Lake Placid in 1800. Arriving via the recently hewn Northwest Bay Road (now Old Military Road), Elijah Bennet and his family settled close to the Chubb River. Dubbed "The Plains of Abraham," these settlers lived in the newly-formed town of Keene for almost 30 years.

Iron ore was soon discovered in the area, and in 1809, the Elba Iron Works opened on the Chubb River. Within a few years, the local iron ore proved unsatisfactory. In 1816, the infamous "year without a summer" brought freezing summer temperatures destroying crops and causing near starvation that winter. In 1817, the Elba Iron Works closed; most workers and all but a few farmers left. Between 1820 and 1840, settlement returned to the Plains. Along the Old Military Road and as far as the Chubb River there were farms. Osgood's was a stagecoach stop, and later Lyon's Inn also became a popular stop. In the 1840s the first school was built.

The early settlers included two New England farmers, Thomas Nash and Benjamin Brewster. They climbed Mill Hill and settled along the shores of Mirror Lake. Lake Placid was a short distance to the north. Within a few years, they owned all the land along Mirror Lake's western and northern shore.

Because the community of Keene was located 12 miles distant, requiring a hazardous and steep road trip, the Plains settlers desired their own township. In 1850, the Town of North Elba was established.

Published writings extolling the wonders and beauty of the Adirondacks with their abundance of game and fish brought outdoorsmen into the area, and the farmers generously opened their homes to them. Meanwhile, wealthy speculators were buying up thousands of state-owned acres for pennies per acre. Some acquisitions were in North Elba.

A short-lived migration of free blacks came about when generous abolitionist, Gerrit Smith, offered urban free blacks acreage to homestead on. Several dozen families accepted Smith's offer and ventured into North Elba's wilderness. Close behind them was John Brown, a white abolitionist farmer from Torrington, Connecticut. Hearing of Smith's offer, Brown, with his family, came north to assist the blacks with farming. He arrived in 1849 and rented a house. By 1855, Brown had his own home. Finding farming difficult and the long winters unbearable, within three years, most of the blacks had left.

Soon, Brown's passion to abolish slavery pulled him away from North Elba. In 1859 his small band of followers attacked the federal arsenal at Harper's Ferry, West Virginia, to get arms for a slave uprising. He was captured, tried for treason, and hung several months later. Brown and some of his followers are buried next to his home, now a state historic site.

Meanwhile, the Nash's farmhouse was enlarging to accommodate the influx of tourists, and a few years later, Brewster built the first hotel. Both stood in what is now the

village of Lake Placid. A hotel building boom then occurred and more than a dozen large, wooden, summer-only structures arose to accommodate the visitors. Hotel construction has continued to this very day.

Stagecoaches and horses provided the only means of travel until the railroad arrived in 1893. State librarian Melvil Dewey took this opportunity to visit the area. In 1895, he purchased a farmhouse on the shore of Mirror Lake and opened his house to his friends. This gathering formed the nucleus of what became the world renowned Lake Placid Club.

The first post office called Lake Placid was opened on Main Street in 1893 and in 1900, the village of Lake Placid was erected within the township of North Elba. It included most of Nash's and Brewsters' property and almost all the Mirror Lake shoreline, including club property, and it extended beyond the Chubb River.

The Lake Placid Club grew rapidly as Dewey purchased farms to expand and service his club. During the winter of 1904–1905, he winterized a small section of the club for members and provided activities such as skiing, tobogganing, ice skating, and skijoring. Although Placidians had engaged in some of these activities long before Dewey's time, his idea of a winter sports vacation had a far reaching and positive effect.

With the growth of the club, members and guests enjoyed an enlarged winter program. At its height, the club owned more than 4,000 acres in the town and accommodated 1,000 guests. It was the community's major employer. Unfortunately, it faltered in the 1970s and died in the 1980s.

In 1924, speed skater Charles Jewtraw, supported by community and club members, made a trip to Chamonix, France, where he won the first Olympic event, a 500-meter speed skating race, and received the first gold medal ever awarded in a Winter Olympics. Inspired by Jewtraw's victory, an American team went to the 1928 Winter Olympics with Dr. Godfrey Dewey, Melvil's son, as manager. Dr. Dewey returned to Europe in September 1929 to represent Lake Placid where he successfully bid for the (1932) III Winter Olympics. Despite the Great Depression, the games were a success with the United States winning numerous gold medals.

The town now had a new speed skating oval, the Olympic Arena for indoor skating events, a bobsled run, a revamped 70-meter ski jump, and miles of cross country skiing trails. The Olympic Arena soon became the center of the town's activities which included a vital summer figure skating program, conventions, and hockey and indoor speed skating events. The other venues were used continuously including international events which brought Lake Placid renown worldwide.

In the 1950s, the town fathers began bidding for another Winter Olympics. In 1974 in Vienna, Austria, they were awarded the (1980) XIII Winter Olympics. The sports' venues were rebuilt and enlarged to meet international standards and a nearby, planned federal prison became the athletes' housing. The games were a huge success. "Welcome World" was the slogan popular then. And, Lake Placid has continued to welcome the sports world in dozens of international sporting events ever since.

The Olympics, plus the recognized beauty of Lake Placid, has had a profound effect. Tourism has grown and many second homes have been built on former farm land. The State of New York, through a 1982 agreement with the Town of North Elba, operates and maintains the venues through the Olympic Regional Development Authority.

CHAPTER 1

THE FIRST 100 YEARS, FARMING AND SETTLEMENT

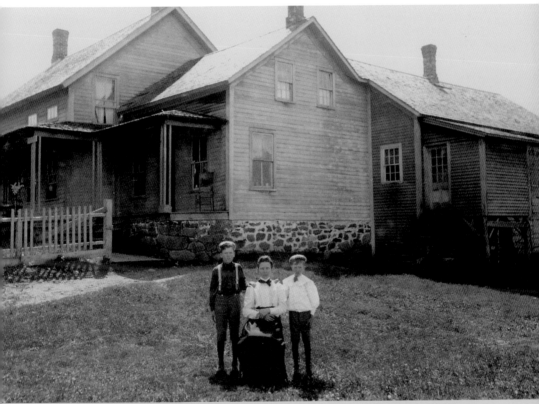

This farmhouse, the residence of five generations of the Torrance family, is located on Old Military Road (Cascade Road). It was built in 1865 by Oren Torrance and occupied a year later. The three people in the photograph, taken about 1900, are Jane Torrance and her two sons, Rollie and Walter, who are members of the second and third generations. Ken Torrance, who now lives there, is Rollie's son.

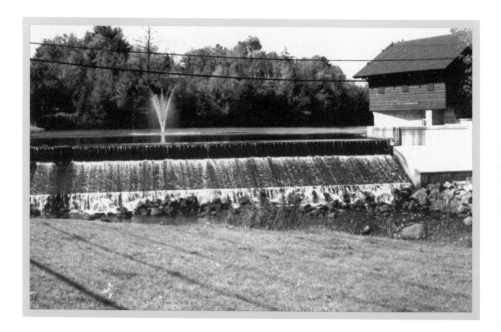

In the early 1850s, a dam was built across the Chubb River to power a sawmill. It also formed Mill Pond. Later a shingle mill was built on the other side of the pond. Both mills ceased operation about 1920. Used for ice-skating until the 1940s, the pond claims speed skater Charles Jewtraw, gold medalist in the 1924 Winter Olympics, as its star skater. Now a scenic and recreational area, the small park beside the pond is named for Jewtraw.

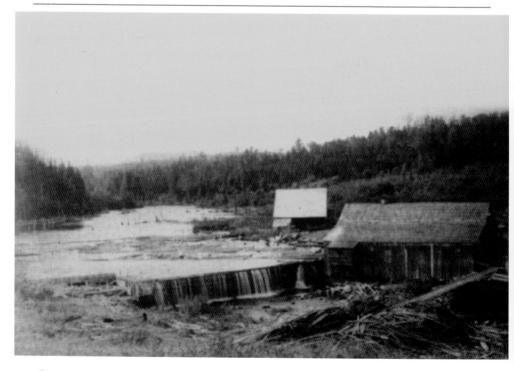

THE FIRST 100 YEARS, FARMING AND SETTLEMENT

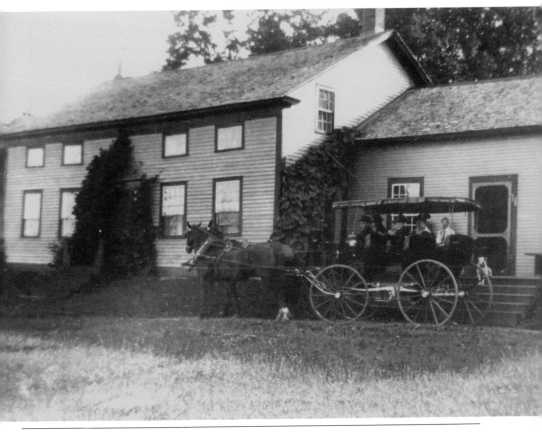

Heaven Hill farmhouse, built in the 1840s, was purchased by Anna Newman who ran the farm and was a local philanthropist. Following her death in 1915, Henry Uihlein took possession of Heaven Hill in 1920. A gentleman farmer, he raised potatoes, Jersey cattle, and had a large sugar bush. He donated his potato fields and maple sugar operation to Cornell University and contributed substantially to the Uihlein Mercy Center. The farm is now managed by the Uihlein Foundation.

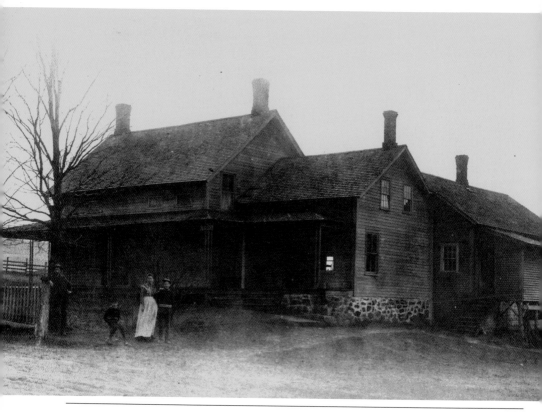

This is the first photograph taken of the Torrance farmhouse (see page 11 for later photograph) which was built on the Old Military Road in 1865 by Oren Torrance. It is the oldest house in the town that has been occupied by one family. Today, Kenneth Torrance and his son Peter, who are the fourth and fifth generations, reside there. The house's far right wing is now the office for Peter's construction business.

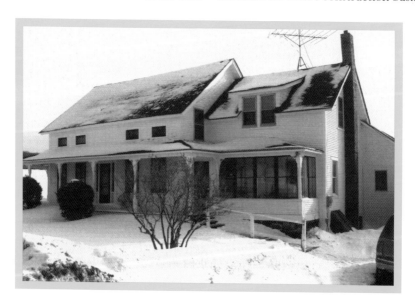

THE FIRST 100 YEARS, FARMING AND SETTLEMENT

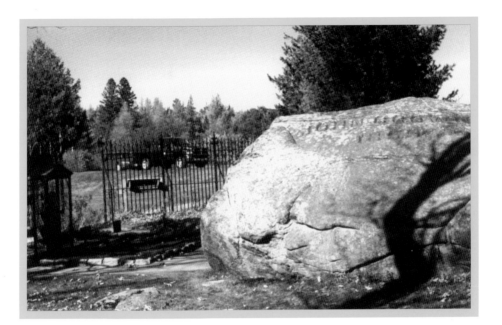

Since abolitionist John Brown's hanging and later burial at his farm in North Elba in 1859, thousands of persons have visited his grave, located beside this huge boulder, on which is carved the year of his death. The early photograph was taken in the late 1890s. Now a New York State historic site, the grave site and boulder, although fenced, are open to visitors, as are his nearby farm house and barn.

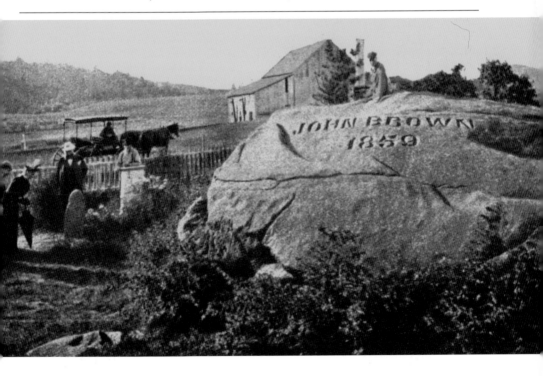

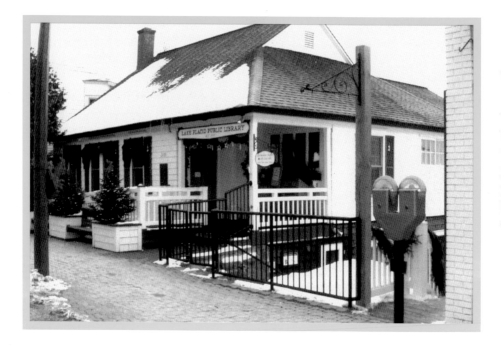

A light snow had fallen on the Lake Placid Public Library in this 1903 photograph. The library was built in 1884 through donations of money and/or materials by the community. In the last 50 years, it has seen changes including a children's room, elevator, and computerization of library data. An addition reached by a glass-enclosed walkway contains a computer room, reference room, and art gallery. The recent addition of a handicap access ramp shows in the contemporary photograph.

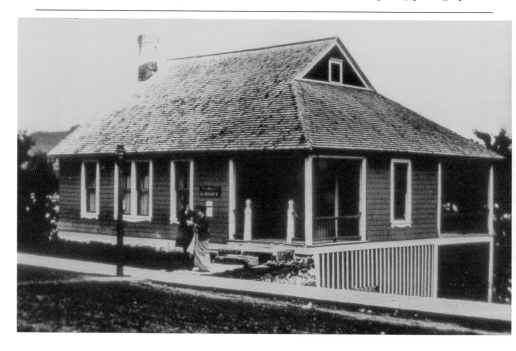

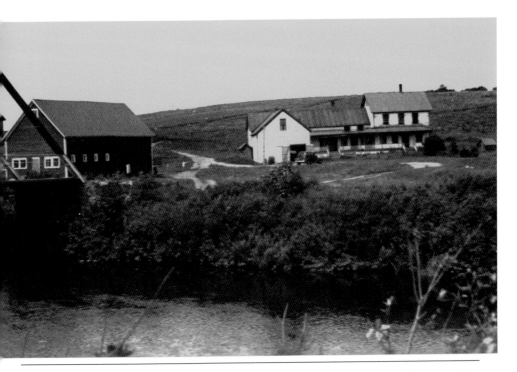

Midrivers farmhouse dates back to the 1860s, when Franklin Thompson, the son of an early settler, established his farm on the West Branch of the Ausable River and built a bridge to it. The Lake Placid Club purchased the farm in the early 1900s and razed the farmhouse around 1920. The barn stood until 1955 when it was struck by lightning. The original bridge was replaced several times. The road now leads to a small development atop the hill.

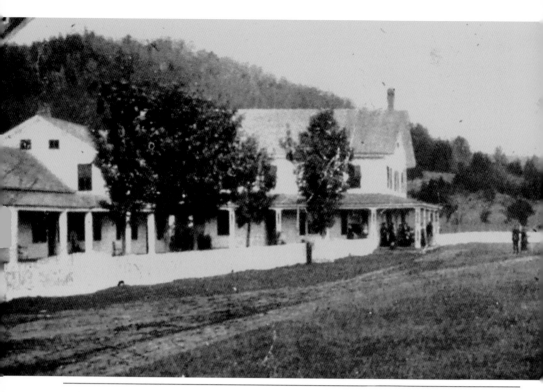

In the 1860s, Robert Scott farmed 240 acres on the Old Military Road. Visitors seeking shelter began to stop by. Soon "Scott's" became a small, respected inn. Scott later gave his niece Martha Ames and her husband the business. They enlarged it as the Mountain View House, which the photograph depicts. A chimney fire in 1903 destroyed the building. The Ames' rebuilt it as a private home. Today known as Olympic Heights, the house provides summer guests with apartments.

THE FIRST 100 YEARS, FARMING AND SETTLEMENT

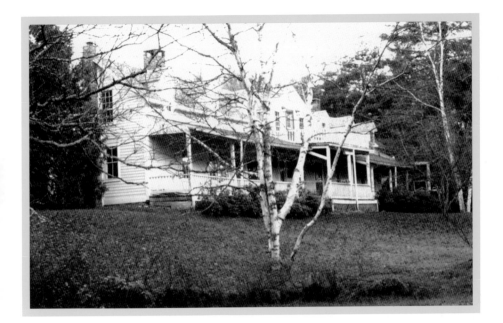

Martin Lyons bought an existing farmhouse on Old Military Road in 1864. He added a wing on either side and opened it as Lyons' Inn. It was a popular stagecoach stop and accommodated tourists. In the 1880s, Lyons sold the inn. It has changed hands numerous times and was damaged by a small fire in 2000. It is expected to reopen, following extensive renovations by the new owner, but without exterior changes, in the near future, as the Stagecoach Inn.

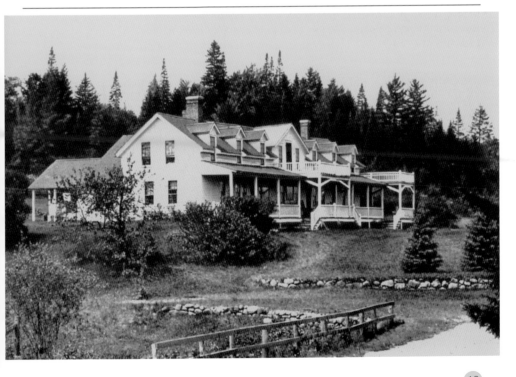

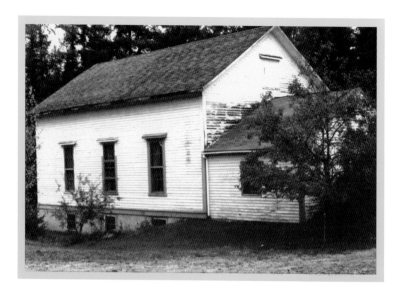

The Union Church, the community's first church, known locally as the White Church, opened in 1875 for use by Baptists and Methodists. Later it became the local Sunday school. The next owner was the Lake Placid Grange. In 1988, it was to be razed and replaced by the United States Olympic Training Center. A small Christian congregation asked for the building. They moved it down Old Military Road, where it now serves them as the Trinity Chapel.

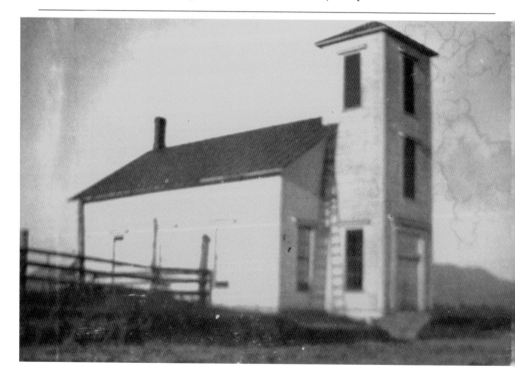

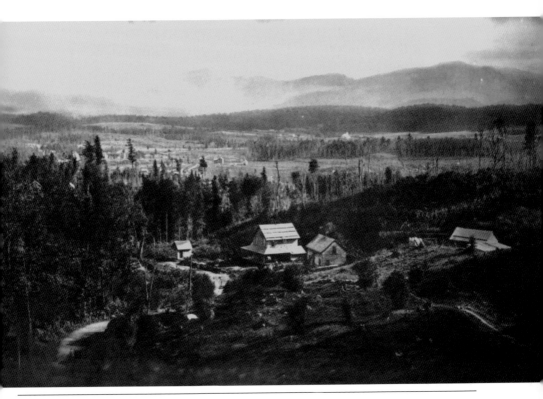

This photographic postcard shows Lake Placid's Main Street as it looked about 1878. Today's Main Street is still as curvy and hilly. Buildings partially visible on the right side of the road in the contemporary photograph are the Olympic Arena and the Lake Placid High School with the same mountain range forming the backdrop. A restaurant, Nicola's-On-Main, is on the left.

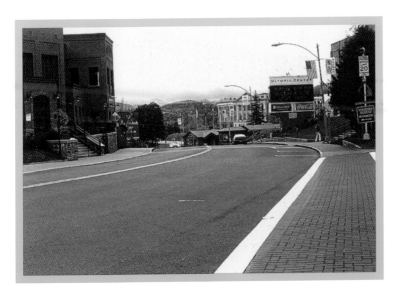

Built by Charles Green in the 1880s, this is one of the oldest Main Street buildings. In this 1914 photograph, taken during the Mid-Winter Festival, a pharmacy occupied it. It is located north of the NBT Bank. Over the years, it has housed a women's clothing shop and a real estate office. It is now occupied by a retail store associated with the Adirondack Museum at Blue Mountain Lake.

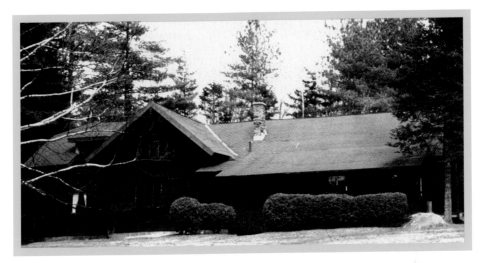

Henry Van Hoevenbergh bought one square mile of Adirondack wilderness before 1880, cut a five-mile road into it, and constructed Adirondack Lodge, a three-story log building, reportedly the largest in the United States. It opened in 1881. Later the Lake Placid Club purchased it. The great forest fire of June 1903 destroyed it, and the land remained vacant until 1929 when the Lake Placid Club built a smaller Adirondack Loj (Melvil Dewey's simplified spelling). The Adirondack Mountain Club now owns and operates the "loj."

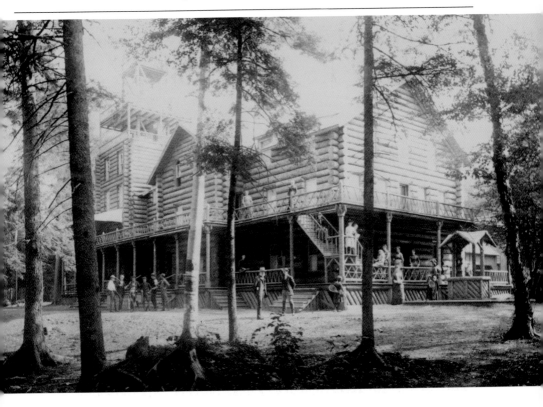

In the 1880s, these farmers were photographed gathering hay for their dairy cattle and horses in the fields along Old Military Road (Cascade Road). In the photograph, the Adirondack high peaks are lightly veiled with clouds. In the contemporary photograph, taken closer to the Old Military Road, the high peaks are clearly visible. This photograph is of a potato field. Potatoes have been an important cash crop in the area since farming began here.

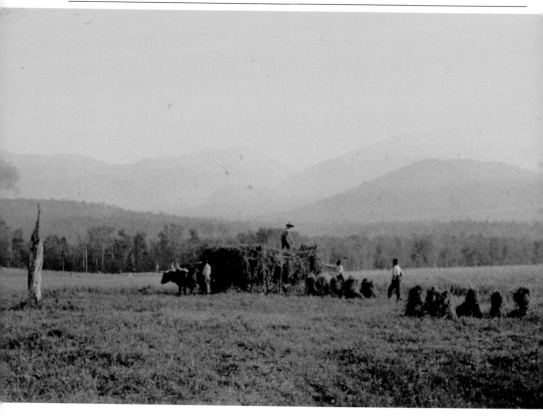

THE FIRST 100 YEARS, FARMING AND SETTLEMENT

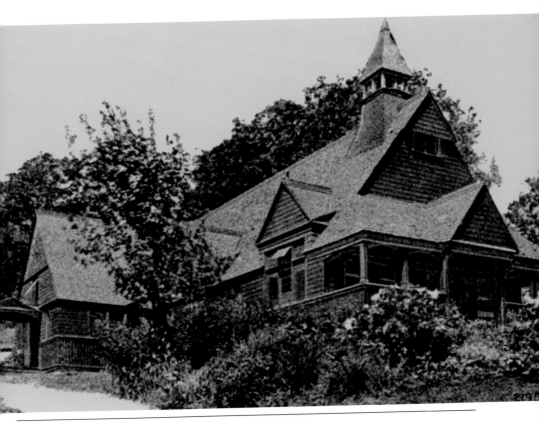

The first Baptist church was built on Main Street in 1888 and served its congregation until 1940s. It stood empty for several years and was purchased by the members of the Church of the Nazarene, who had it torn down in 1967. The Church of the Nazarene built the stone church in the contemporary photograph. In 2005, the congregation sold the church to the Adirondack Museum of Blue Mountian Lake. In the future, it is set to be replaced by a small museum.

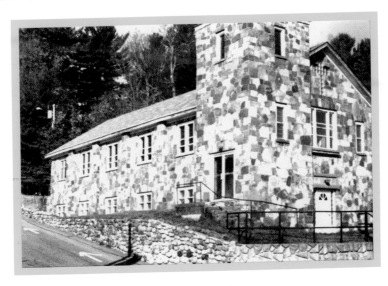

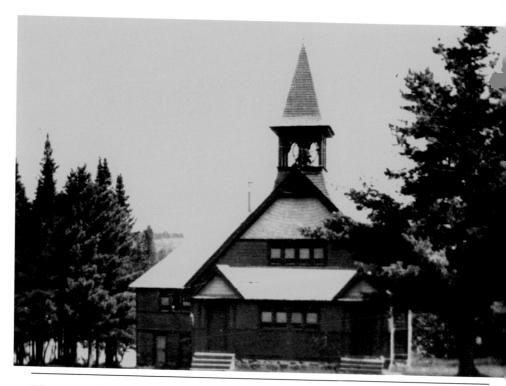

The first Methodist church was constructed on Main Street in 1888. It served the community for more than 34 years. In the 1920s, the congregation decided to build a new stone church. The old church was sold, moved, and stands as a business on School Street. The new church, dedicated in 1925, still serves the Methodist congregation. Erdman Hall was added later as a meeting place for social events.

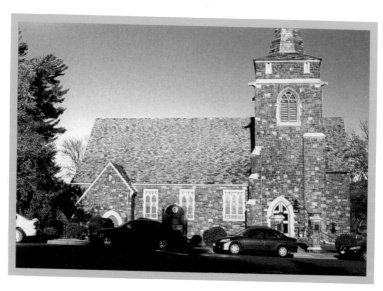

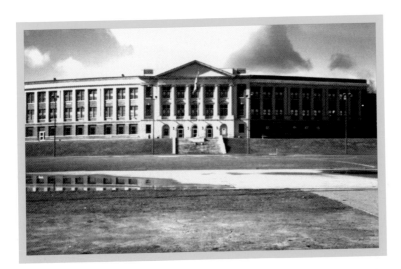

The first section of Lake Placid's first high school was built in 1888 on Main Street, across from the present town hall. By 1902, with a growing school population, two additions had been made as the early photograph shows. In 1922, the first section of the present school, now the Lake Placid Central Middle/High School, was erected as today's south wing. In 1934, a Works Progress Administration program completed the large addition. The first school was dismantled and moved in the 1920s to the club property.

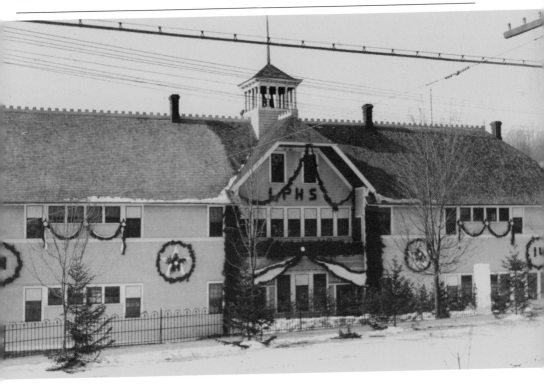

The Chellis House on the south side of Sentinel Road, just beyond Lamb Lumber Company, was built in the late 1800s by George Chellis, who reportedly owned and operated the sawmill on what is now Mill Pond. The house existed until the late 1960s when, because of aging, it was torn down. Lamb Lumber, which owned the property, now stores its building materials there.

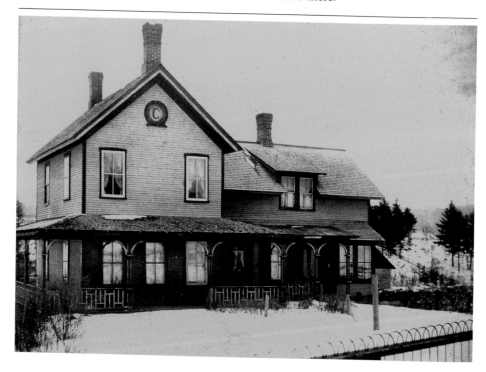

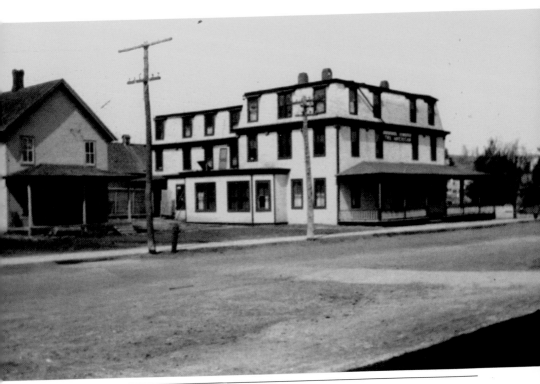

The American House was built by James, Matthew, and William Hurley in 1893 to provide lodging for persons arriving by train at the new Delaware and Hudson Railroad station located across the street. The hotel stood for nearly 50 years but was destroyed by fire in the 1940s. Later a paper company built a warehouse on the site. That building now houses Hurlbert's, a plumbing supply business. That is the same private home in both photographs.

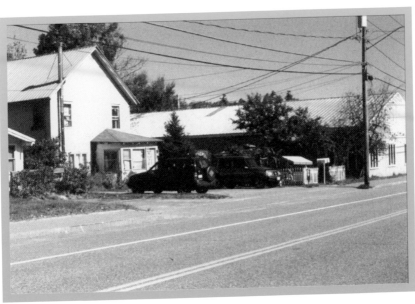

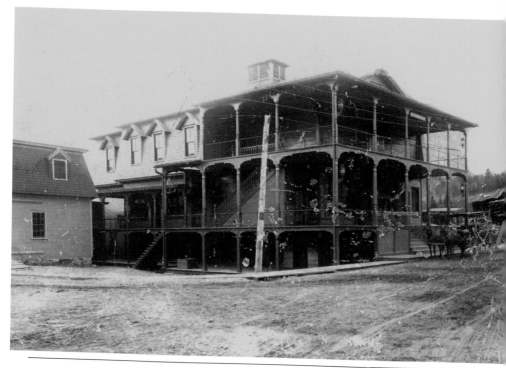

Built in 1895, the George White Opera House was three stories high and contained a 400-seat theater on the third floor and White's Hardware store on the second floor. The first floor was at street level, and the Chubb River was right next to it. The road was raised to avoid flooding, and the first floor became the basement. Today after many renovations, the building now houses Lisa G's Restaurant at street level and an apartment on the second floor.

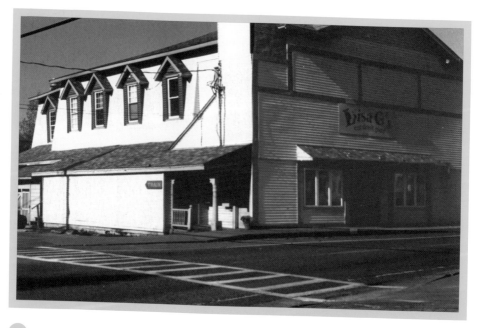

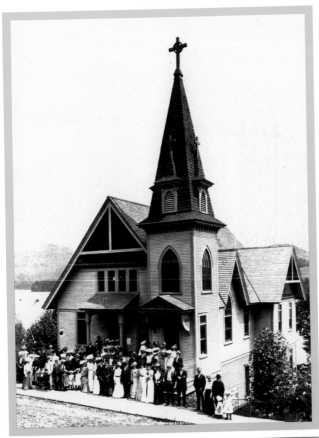

The first St. Agnes Roman Catholic Church was built on Main Street in 1896 on the shore of Mirror Lake. The wooden church served the community until 1905, when a larger church was built atop Saranac Avenue hill. Evidence of the original church remains to this day as noted in the windows and roofline. It next served as Lake Placid Hardware. Remodeled a few years ago, it is now home to Alpine Meadow and Ben and Jerry's.

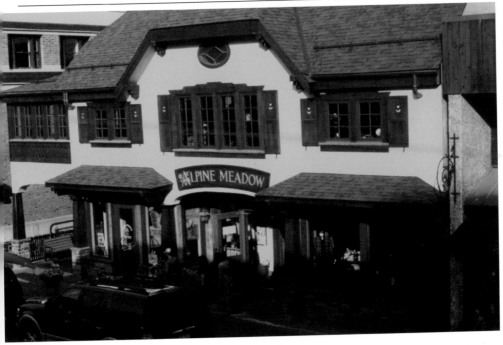

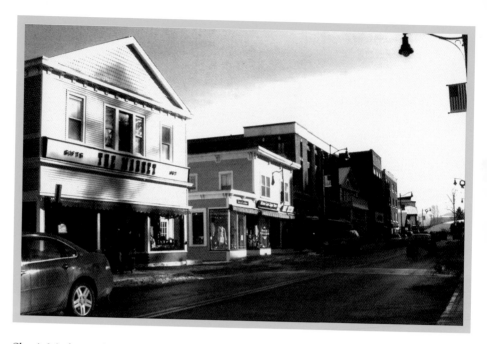

Shea's Market, a family business, was built in 1896 as one of the earliest grocery and meat markets in the middle of the growing Main Street business district by James Shea. A fire in the 1930s necessitated a roofline change and renovations. It was a popular market until it was sold in 1976. It is now the Market, an upscale gift shop. The two buildings on the right were also Shea's businesses. One was a liquor store.

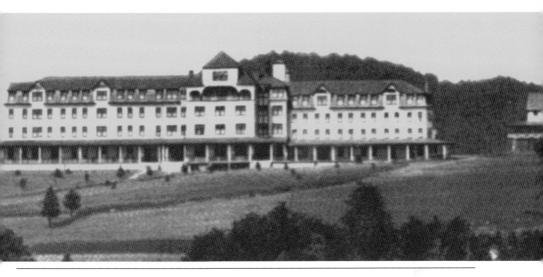

The Grandview Hotel, built in 1878 as a small hotel, was located on top of the hill west of Main Street. By 1900, it had grown to the size pictured and was operated by several owners until 1956. It closed permanently then and was razed in 1961.

The Holiday Inn was built on the site. The Serge Lussi family has operated and expanded it since. In 2005, they enlarged and renamed it the Crowne Plaza Resort and Golf Club. Only a section of the contemporary resort is visible.

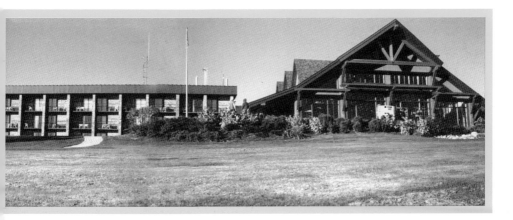

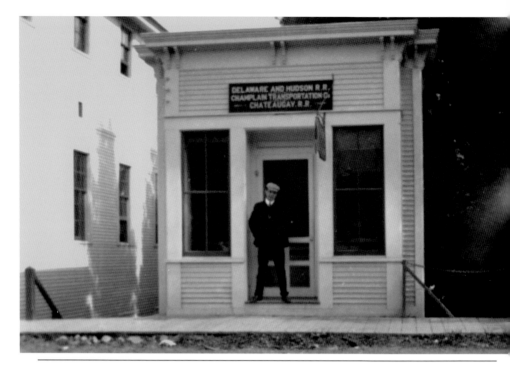

In 1893, the Delaware and Hudson Railroad brought railroad service to Lake Placid from Plattsburgh and soon opened this ticket office on Main Street next to the Parish House. The railroad discontinued this office after a few years.

Today a larger, one-story building stands at this site. There is no record as to whether the present building was a new building or an enlargement of the Delaware and Hudson Railroad ticket office. An antique store now occupies this building.

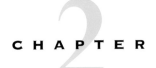

CHAPTER 2

VILLAGE GROWTH AND THE TOURISM INDUSTRY

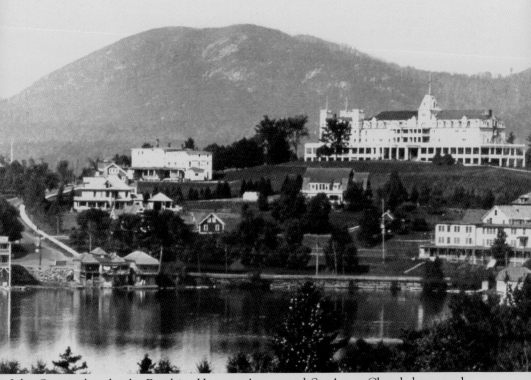

John Stevens bought the Excelsior House in 1878. It was destroyed by fire and quickly rebuilt. Then called the Stevens House, it stood high above Mirror Lake. It housed many illustrious visitors. This 1920s photograph includes the Stevens House Annex and St. Agnes Church lower and to its left, the Lakeside Inn on the shore of Mirror Lake and Main Street businesses backing on the lake. Saranac Avenue is the road on the hill. The Stevens House was razed in 1947.

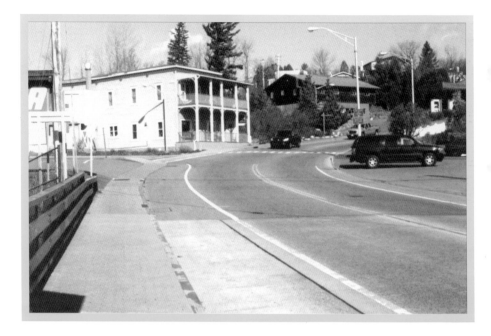

This 1900s photograph shows Main Street at the bottom of Mill Hill, before the road was raised to stop the Chubb River from flooding over the bridge. In both photographs, the building, upper left, has seen little outward change over the years. In the 1900s, it housed a millinery shop, and from 1915 to 1936, the Newman Post Office. The Raeoil Corporation then occupied it. An antique shop was next. In 1996, the Down Hill Grill became the present occupant.

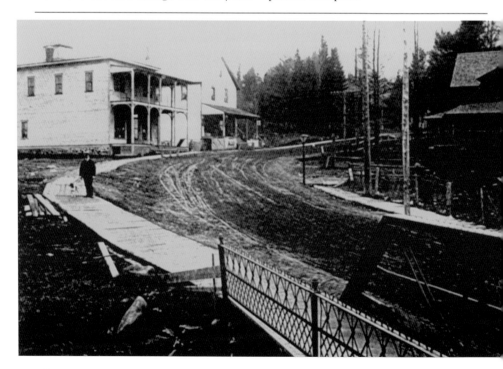

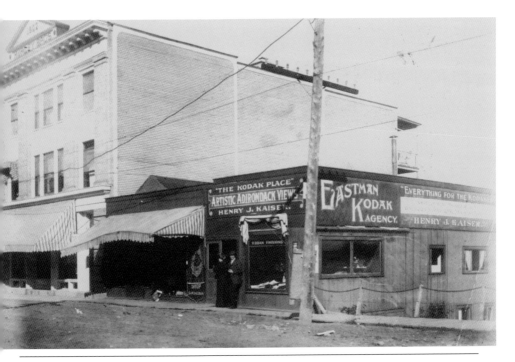

Future industrialist Henry J. Kaiser opened his first business as a teenage partner in a photography shop on Main Street about 1903. After buying out his partner, Kaiser operated the business for several years and then moved south. Today on the site of his former business, there is an apartment building with retail stores on the ground floor and more on the lower level. A plaque commemorating Kaiser's first successful business endeavor is on the wall of the building.

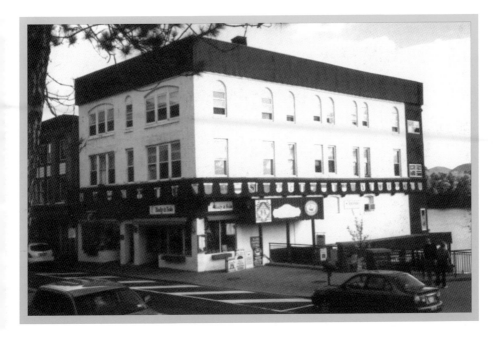

In the early 1900s, Main Street was raised as it crossed the Chubb River, putting this home, which backed on the river, below street level. Several years later, the property was taken over by Lamb Lumber Company, and the house was torn down. A lumber storage area now replaces it. The contemporary photograph shows the former IGA building on the left. It replaced the apartment house seen in the historical photograph.

Opened in 1900, the Pines Inn was a 25-room, three-story, upper class inn on Saranac Avenue that the Stickneys owned and operated for 23 years. They sold the inn in 1923. The new owner enlarged it to six stories and renamed it Hotel St. Moritz. Since then, various owners have operated it as the St. Moritz. In 2003, it was purchased by Frank and Jill Segger, who gave the inn its original name, the Pines Inn.

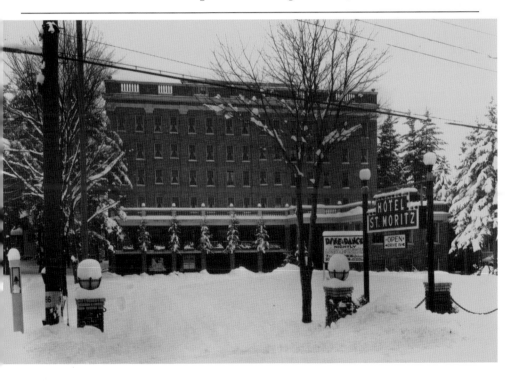

The early photograph of Main Street, then called Lake Street, was taken about 1900. Note the dirt road. Some of the buildings on the left were destroyed by fire in 1919. The contemporary photograph was taken as close to the original spot as the first one, as the curved curbing on the right indicates. This is the intersection of Main Street with Saranac Avenue. Today the Hilton Lake Placid Resort replaces the lawns and trees on the right.

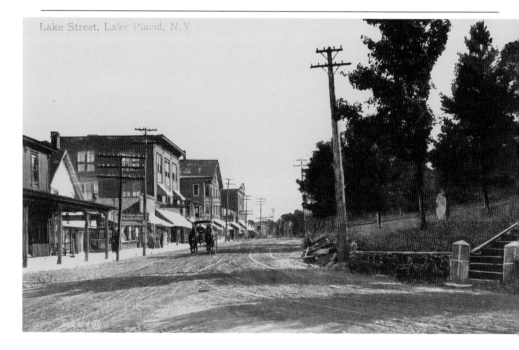

Lake Street, Lake Placid, N.Y.

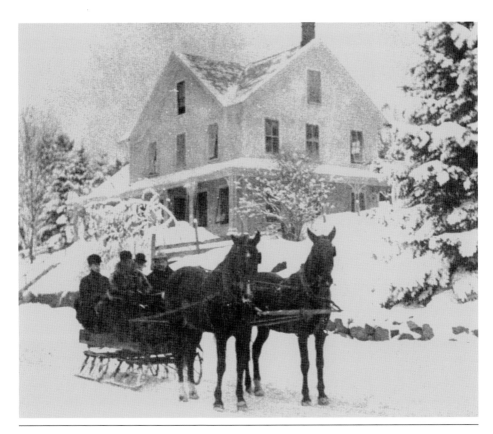

In 1880, a private home existed on Main Street. Harvey Alford became the owner in 1919 and enlarged it as Alford's Inn. In 1927, Frank Swift bought it and renamed it the Lake Placid Inn. It then changed hands several times as an inn. In 1989, Gregory Peacock became the owner and remodeled the building by removing the lawn in front to access the lower level. His business is called Adirondack Decorative Arts and Crafts.

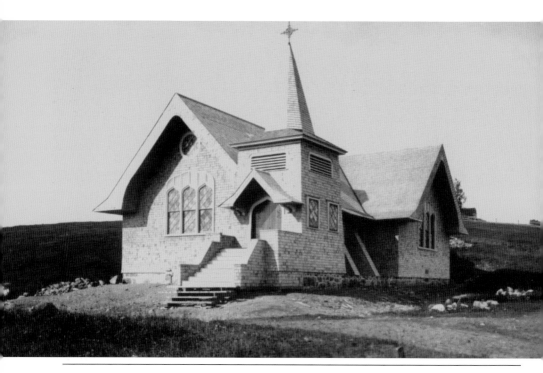

St. Eustace-by-the-Lakes, an Episcopal church, was built in 1900 on the shore of Lake Placid. It was too far away for winter use, so a smaller church, St. Hubert's Episcopal Church, was built on Sentinel Road in 1902 closer to the winter residents. In 1927, St. Eustace-by-the-Lakes was disassembled, each board numbered, and the church was rebuilt on Main Street. The steeple was moved to the left side to make it accessible from the street. St. Hubert's Episcopal Church was then sold.

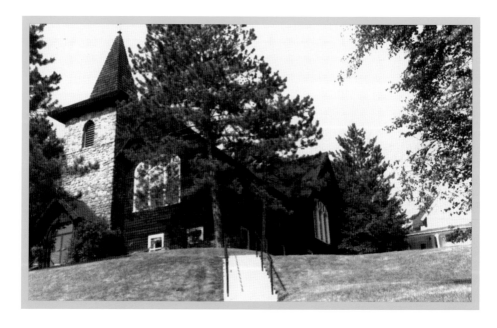

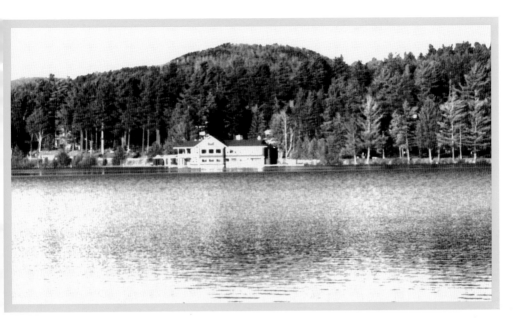

Taken about 1905, this photograph shows the Lake Placid Club's complex of buildings on the east shore of Mirror Lake. Developed by famed librarian Melvil Dewey in 1895 as a membership club, it was important in Lake Placid's history. Before 1910, Dewey had developed additional club buildings on the south shore of the lake. The buildings shown, except for the boathouse, were razed by 1957. Completely renovated, the boathouse is now a summer restaurant.

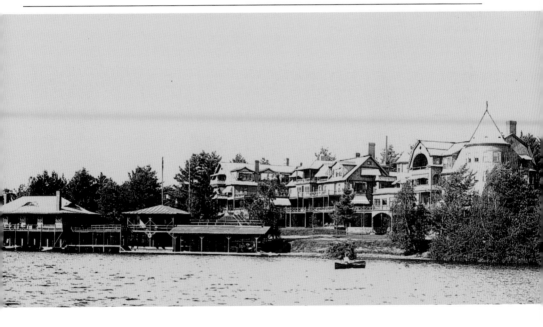

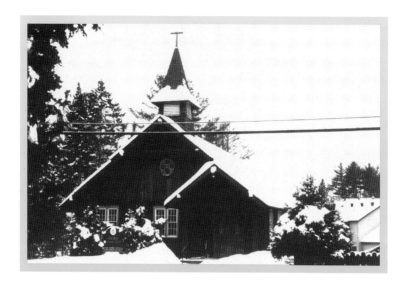

St. Hubert's Episcopal Church was built in 1902 on Sentinel Road to serve as the winter church for the Episcopalians. St. Eustace-by-the-Lakes on the shore of Lake Placid was too far from the villagers. In 1927, St. Eustace-by-the-Lakes was dismantled and rebuilt on Main Street, and St. Hubert's was sold to the Pilgrim Holiness Church. In February 1954, a fire razed the Pilgrim Holiness Church. Immediately the congregation rebuilt it in a similar style. It still serves them today.

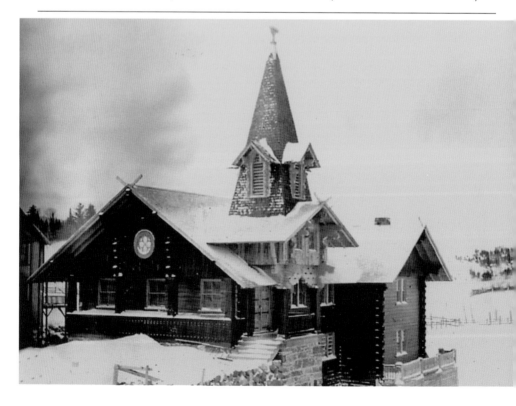

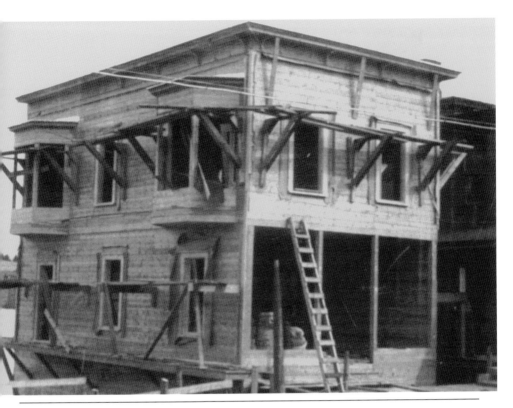

The Joseph Williams family constructed this building on Mirror Lake at the north end of Main Street in the 1900s. It has housed numerous businesses over the years. Roy and Millie Johnson bought the building in the 1970s, and in 1992, they opened the children's shop, Far Mor's Kids, which they named after their Swedish grandmother. Far Mor's Kids has changed hands several times. Millie still owns and lives in the building. A sports bar is at lake level.

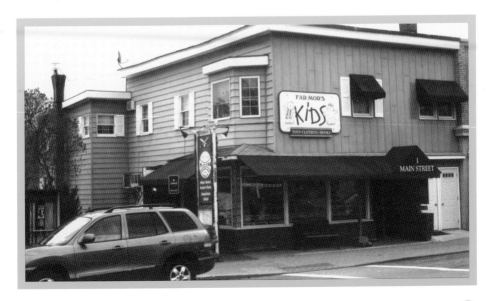

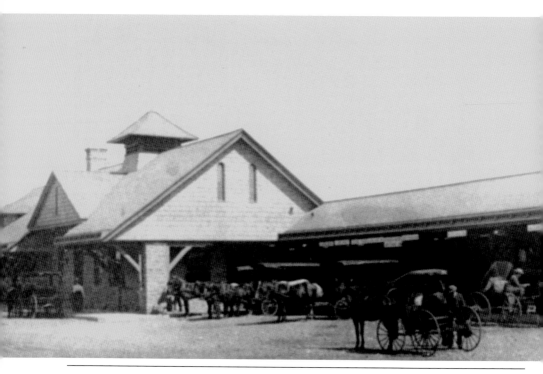

Lake Placid Railroad station was built in 1904, replacing a frame house used as the station. It served the railroad until 1962, when passenger service ended. In 1967, the Brewster sisters purchased the station and donated it to the Lake Placid-North Elba Historical Society for use as a museum. Over the years, the platform canopies were removed, and a portico was added. The History Museum, open each summer, also serves as a ticket office for the Adirondack Scenic Railroad.

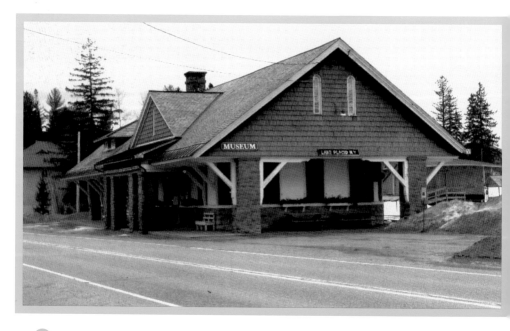

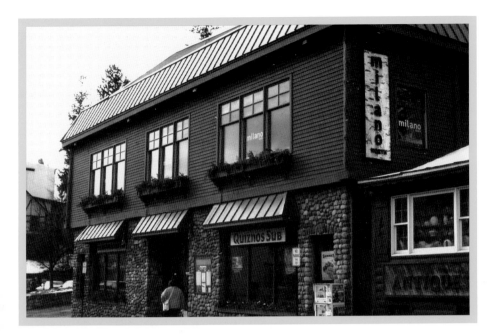

Williams Garage was built in 1904 on Main Street shortly after the first car arrived in Lake Placid. In 1919, Francis Walton became owner, followed by Julian Reiss in 1928. His business, Northland Motors, moved upstairs during World War II. The Grand Union moved into the Main Street level. Reiss built the adjoining two-level parking lot. Since the Grand Union moved, several businesses have occupied the building. The present ones are Starbucks and Quizno's, and Milano North upstairs.

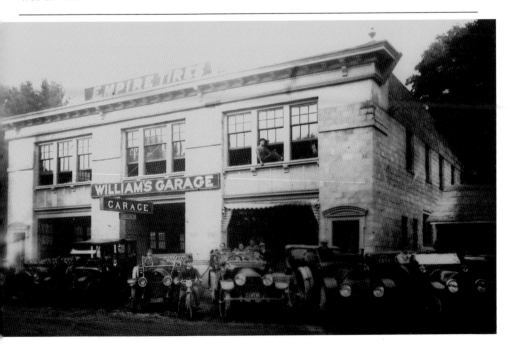

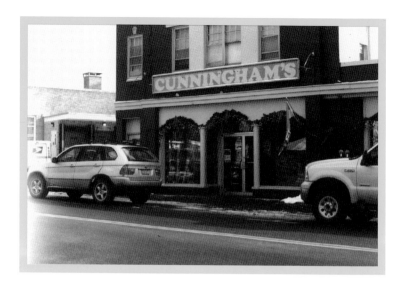

The Lake Placid Volunteer Fire Department celebrated its 100th birthday in 1905. Within a few years, this firehouse was built on Main Street, with an apartment and meeting room upstairs. This 1925 photograph shows the arrival of a new fire truck. As the community grew, a ladder truck was needed, and two more bays were added. In 1996, the village built a larger firehouse on Mill Pond Drive. The old firehouse became the home of Cunningham's Sport Shop.

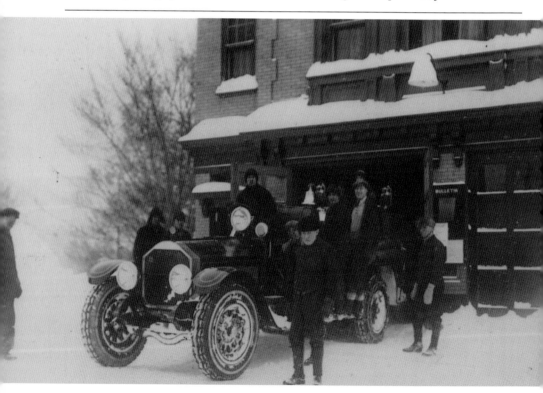

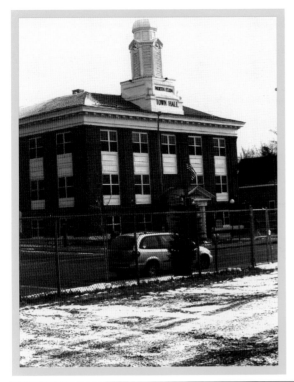

From 1850, when the Town of North Elba was formed, until a town hall was built on Main Street, town business was conducted in a variety of buildings. In 1907, a three-story, metal-covered structure with porches became the first town hall. In February 1915, fire destroyed the stately building. It was quickly rebuilt of brick. Several renovations have occurred over the years. During the 1932 and 1980 Winter Olympic Games, space in it was utilized by both Olympic Organizing committees.

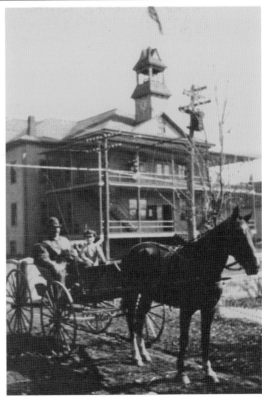

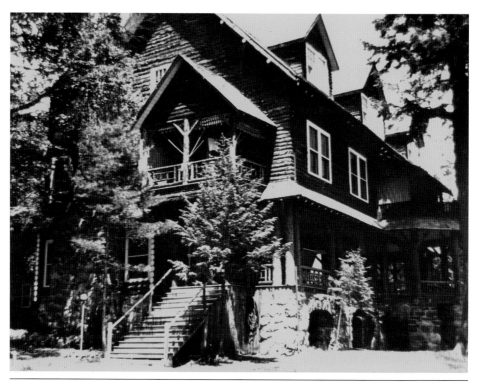

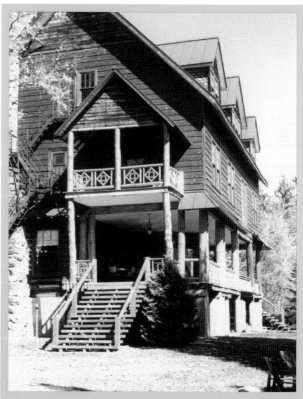

Camp Minnowbrook, built in 1908 on the west shore of Placid Lake, is reached by boat. It was the summer home of the Bahnsen Family until 1948. Lothar and Paula Epstein bought Camp Minnowbrook and opened a children's music camp there, which they ran for 30 years. When the Epsteins sold, the property was subdivided. Shown in the photographs is the camp's main building, which is now undergoing renovations by a new owner.

VILLAGE GROWTH AND THE TOURISM INDUSTRY

The National House, a four-story, 60-room hotel, was built on Station Street across from the railroad station in 1909 by Henry Allen. Tom Leahy became the owner in 1916. During the 1918 influenza epidemic, the hotel temporarily served as a hospital. In 1954, then owner R. C. Prime gave the aging building to the junior chamber of commerce. They torn it down, and a VFW hall was built on the site. Today with renovations, the VFW hall is a private residence.

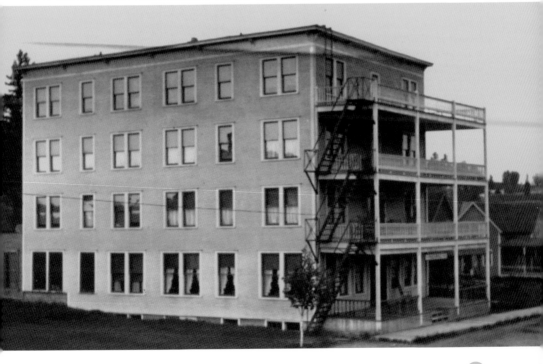

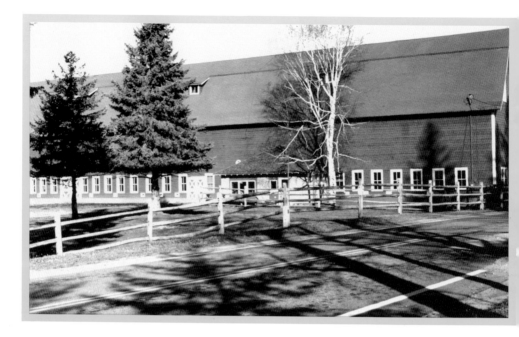

The Red Barn on the River Road is about 200 feet in length and dates back to 1909, when the Lake Placid Club built it to house its Holstein herd. The barn had "cement floors, running water and all modern appliances," according the Lake Placid Club notes. Known as Intervales Farm, it is presently owned by Woodlea Farms and is in excellent condition. The old dump, reached from Cascade Road, is visible on the left in the old photograph.

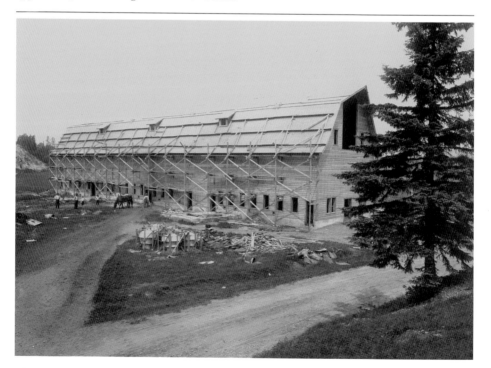

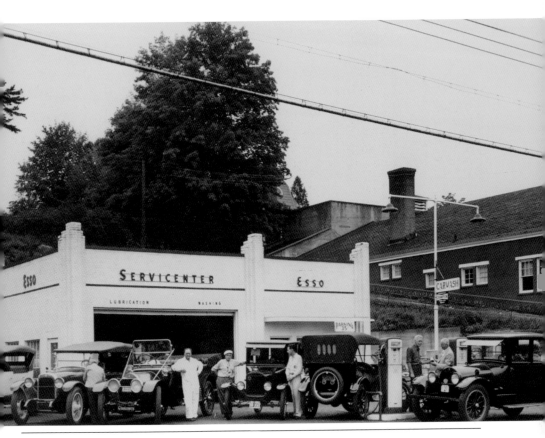

Bobsledding gold medalist Curtis Stevens opened an Esso gas station in the late 1930s on Main Street, next to the Palace Theatre, which he operated until 1980. The building, after several other uses, became the Great Adirondack Steak and Seafood Restaurant in 1986, and it still serves the public. In the 1950s photograph, Stevens is shown with members of the Glidden antique automobile tour as they passed through the village.

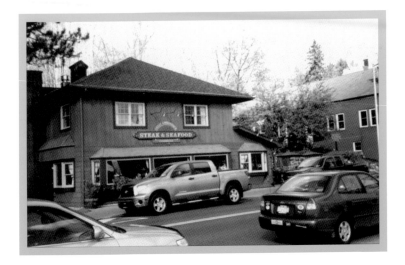

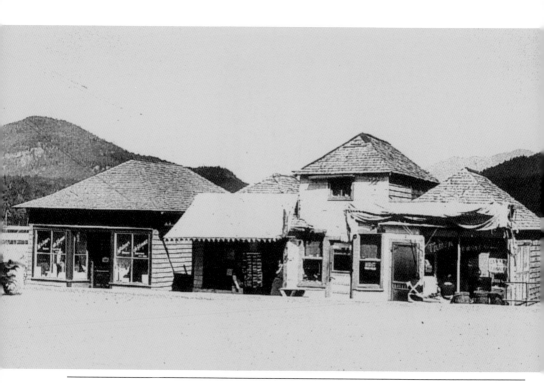

About 1910, this group of summer-only stores was built at the foot of Saranac Avenue and Main Street on the shore of Mirror Lake. Their demise date is uncertain, but by the mid-1930s, they no longer existed. Today Brewster Park, dedicated to one of the villages founding fathers, Benjamin Brewster, occupies the shoreline and offers one of the few unrestricted views of Mirror Lake from Main Street.

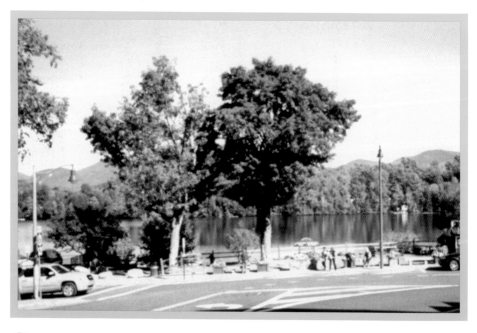

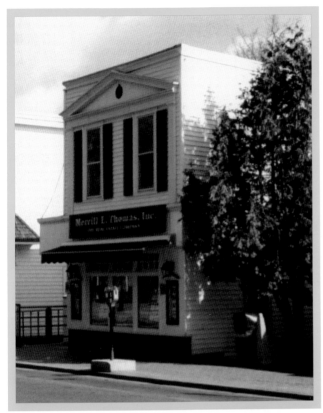

Built between 1908 and 1913, this Main Street building stands just north of the Lake Placid Public Library. Its first occupant was a candy store as the sign on the window indicates. Over the years, the store held a variety of businesses. There have been apartments both upstairs and below street level. In 1943, it became the home of the Merrill Thomas Real Estate office, which still owns and occupies it.

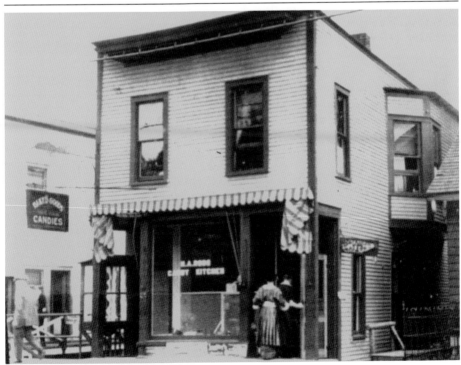

The Popular Bakery opened on Main Street's Mill Hill in the early 1900s, just one door down Mill Hill from the corner and next to Willis Wells Store, now Dimon Sports. Deliveries of bread and baked goods were made daily to restaurants, hotels, and private homes. The business was run by E. W. Skerrett for some 20 years. Sold in 1937, it closed in 1938. The building has since been renovated and is now all apartments.

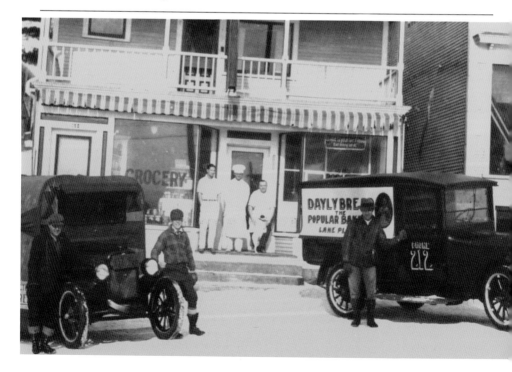

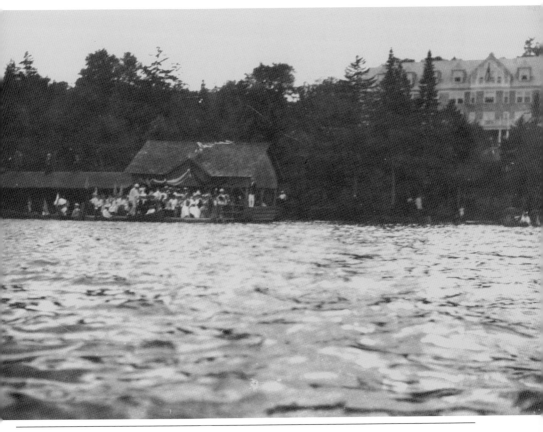

In 1882, Westside Inn was built on Placid Lake's west shore. Sold in 1891, it was renamed Whiteface Inn and then torn down. It was replaced, and in 1909, fire destroyed that inn. It was in 1915 that Whiteface Inn was rebuilt including boating facilities. In the 1980s, everything in the charming inn was sold, and it was torn down. Today the present owners operate as the Whiteface Club, a fine condominium resort with golf, tennis, and boating facilities.

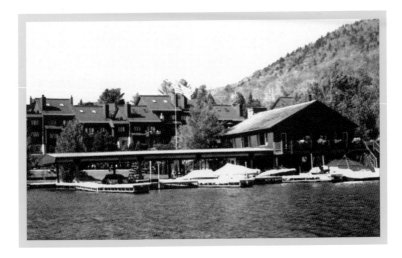

The Fawn Ridge Ski Center, built by Clarence "Khaki" Lamb in the early 1940s, was on the outskirts of Lake Placid village. The second ski area in the town after the town-owned Scotts Cobble, it was served by a rope tow, later a Poma-lift, and had a small lodge and snack bar. It closed in 1977. In 1980, a 38-lot subdivision replaced it. A new road from Saranac Avenue which bridges Outlet Brook serves the numerous homes now located there.

The Hotel Belmont existed as early as 1900 on Saranac Avenue. It was a summer operation until the late 1930s when it was winterized. Run by John Shatz for more than 25 years, it was eventually taken down. In 1986, the vacant property was purchased by the law firm of Smith, Dwyer and Bliss. The new one-and-a-half story building, built in 1988, now houses the law offices of Briggs and Norfolk, LLP, and the law office of Timothy Smith.

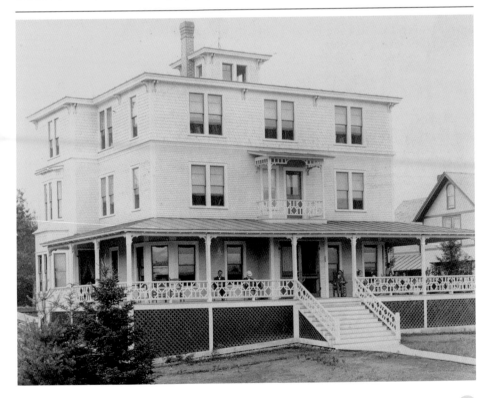

An early view of Main Street, looking north around 1920, shows the Lake Placid Public Library, which has stood there since 1884 near several shops, including a sport shop next door with its awning spread. The current photograph shows the remodeled library and a real estate office occupying the former sport shop. The building, far left, is the same today after a face-lift.

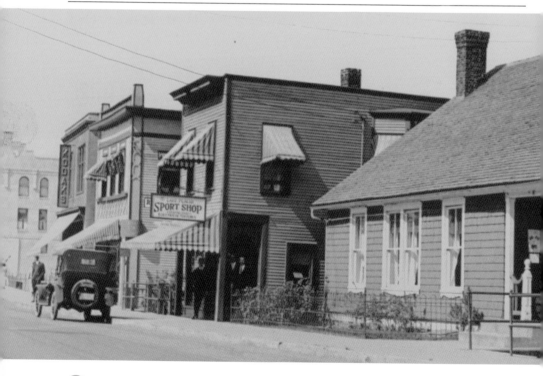

VILLAGE GROWTH AND THE TOURISM INDUSTRY

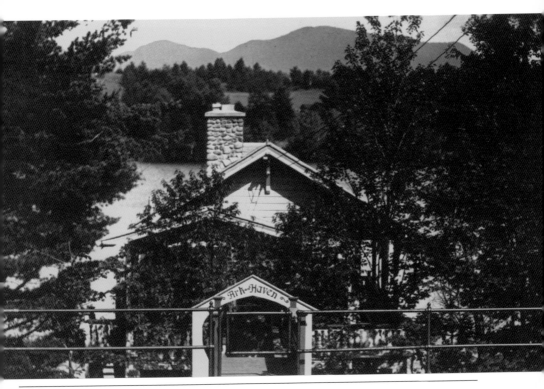

Ark Haven Tea Room was built in the 1920s on Main Street on the shore of Mirror Lake. A popular summer eatery, it was operated by the Otis family until the late 1930s when it was sold, torn down, and replaced by the Frances Brewster Shop, a women's store. That business closed in the 1970s, and several years later, a fire destroyed the building. The present building houses Eastern Mountain Sports on the ground floor and several offices above.

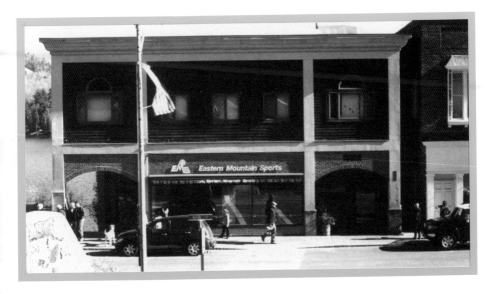

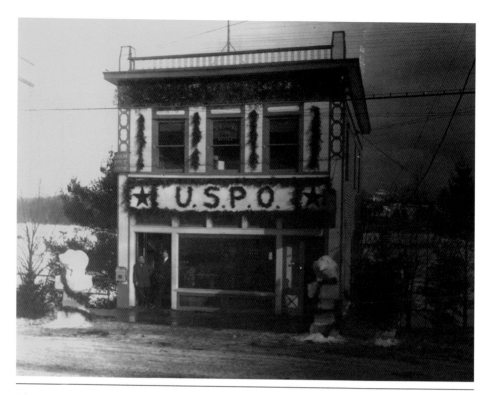

The first post office called Lake Placid was opened in 1893 in Stickney's building on the northern end of Main Street as shown in this 1914 photograph. Newman post office had been established in 1891 at the south end of the Main Street to save residents the long trek up Mill Hill. In 1936, with the construction of the brick post office on Main Street, a Works Progress Administration's project, the two post offices were merged as Lake Placid.

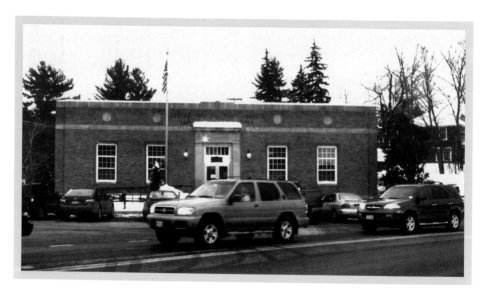

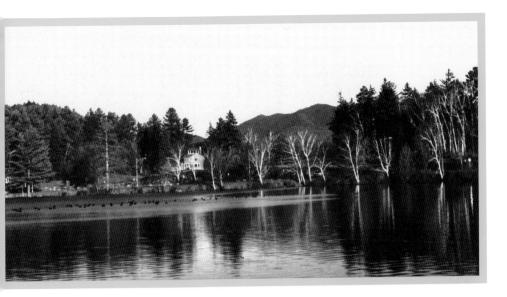

The Lake Placid Club reached its peak in the late 1960s. Foreclosure followed in the 1980s, after a decline in membership and reservations. In October 1992, an arsonist burned the main building seen on the right. New owners razed all the buildings in the photograph. The cottage shown stood behind them. All that remains is the driveway's stonewall. The club's 1,200 acres, three golf courses, and other amenities are now part of the Crowne Plaza Resort and Golf Club.

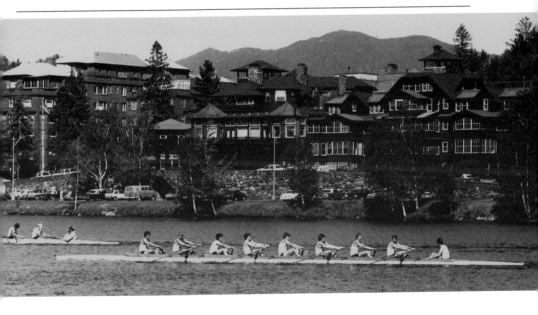

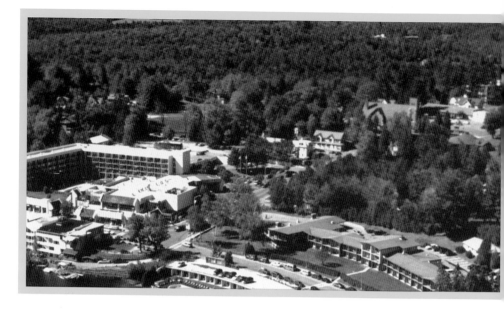

The Lake Placid Hilton, built by the Roland family in 1979, sits on the site of their former inn, the Homestead, which they owned and operated since 1922. When the Homestead was razed, several other homes on the corner of Main Street and Saranac Avenue also fell under the wrecker's ball. The Lake Placid Hilton, soon to be High Peaks Resort, includes the two-story Lakeside, which has motel units and a swimming pool on Mirror Lake's shore.

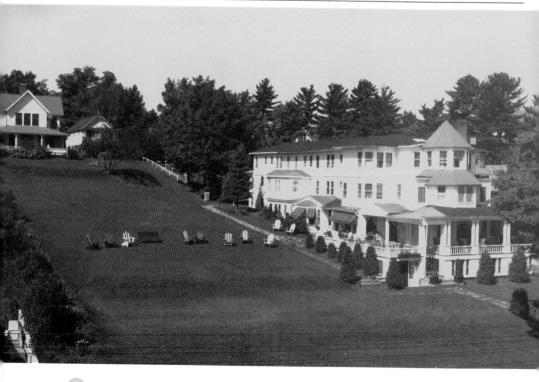

VILLAGE GROWTH AND THE TOURISM INDUSTRY

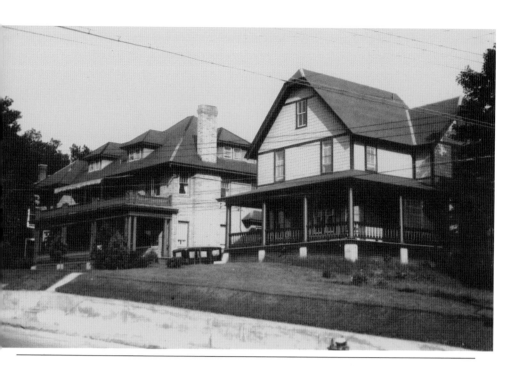

The building on the left was the home of Dr. Merritt Proctor on Lake Placid Club Drive. In 1923, it was purchased for use as Lake Placid General Hospital. The house on the right became the nurses' quarters. In the 1950s, a new hospital was built. These buildings were razed in the 1970s, and an inn erected. After several occupants, it was purchased in 1990s by the National Sports Academy, which now provides secondary education and training for aspiring athletes.

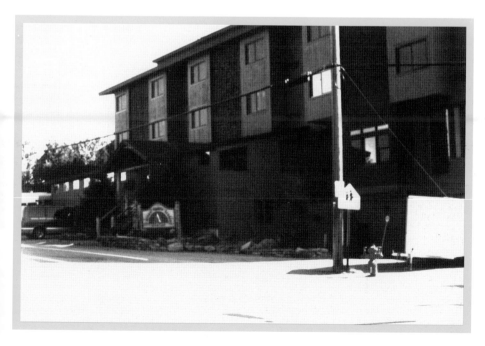

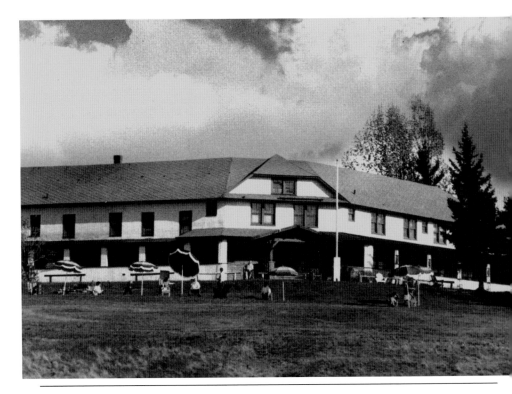

The Alpine Inn on Saranac Avenue dated back to the 1920s and served vacationers for more than 35 years. Purchased by the W. Alton Jones Foundation in the 1950s, it was razed, and the W. Alton Jones Cell Science Center was constructed on the property. The center was a major research laboratory until 1990s. Upstate Biotech occupied the property next until 2002, when it was taken over. Followed quickly by another take over, the facility was closed and is currently for sale.

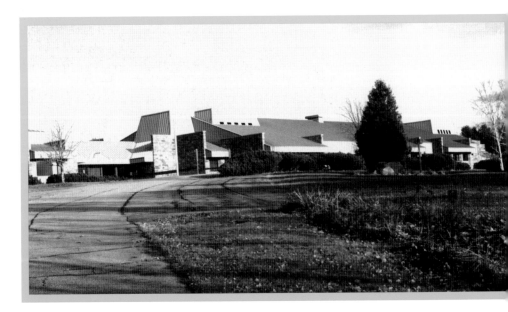

VILLAGE GROWTH AND THE TOURISM INDUSTRY

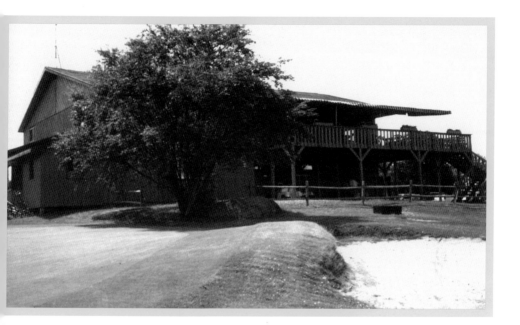

The Lake Placid Country Club's first nine holes and clubhouse were built in 1925 by private enterprise. Seymour Dunn was the course architect. Sold to the Town of North Elba in the 1930s, it was enlarged into an 18-hole course. In 1967, it was renamed Craig Wood Golf and Country Club after native son Ralph "Craig" Wood, 1941 Masters and the U.S. Open Champion. The new two-story clubhouse was built in 1983 near the site of the former one.

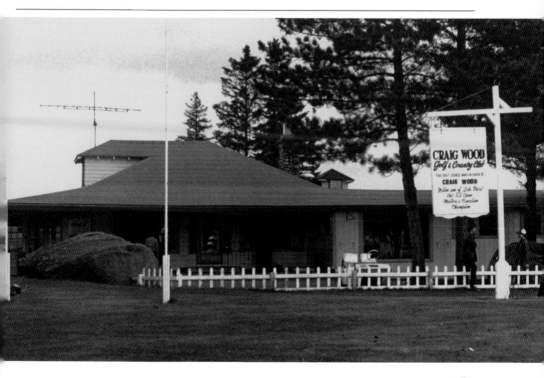

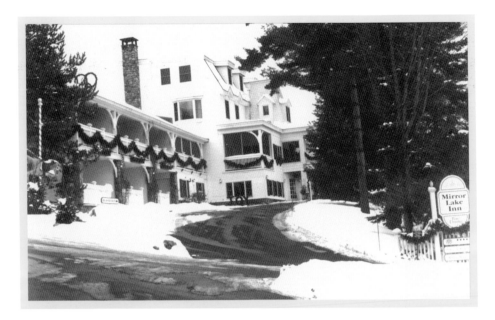

The building housing the first Mirror Lake Inn was built in the 1880s. In 1925, Climena Alford Wikoff became proprietor, and it became one of the village's most popular hostelries. In 1976, Edward Weibrecht purchased it. A winter fire in 1988 destroyed the original building. It was quickly rebuilt, with numerous interior amenities, to resemble its predecessor. The early photograph was taken in 1949 when the Wikoffs still ran the inn. The Mirror Lake Inn is now a four-star hotel.

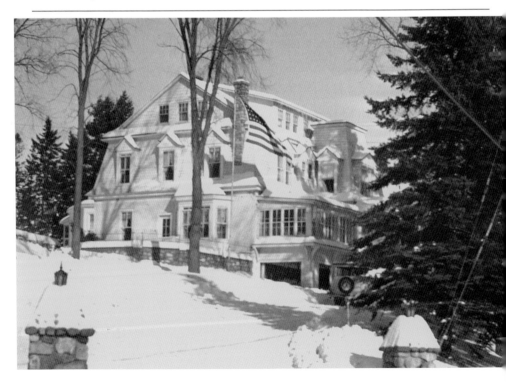

CHAPTER 3

GROWTH CONTINUES

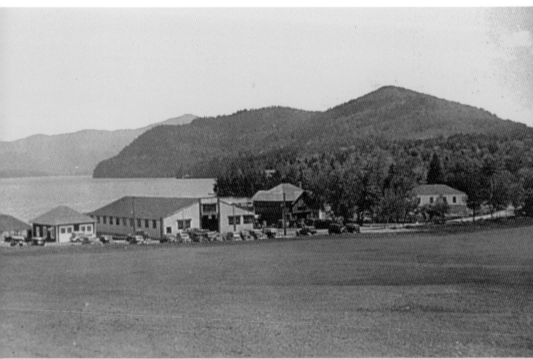

A marina on Lake Placid dates back to the 1890s, when use of the lake was growing rapidly. In 1897, Albert Billings, an Adirondack guide-boat builder, opened Billings Landing to service the lake's property owners. He died in 1903. The following year, his employees Thomas George and Herman Bliss bought the business. This photograph, taken about 1939, shows the George and Bliss building far left and the marina's shop left of center. Whiteface Mountain is just visible behind the darker peak.

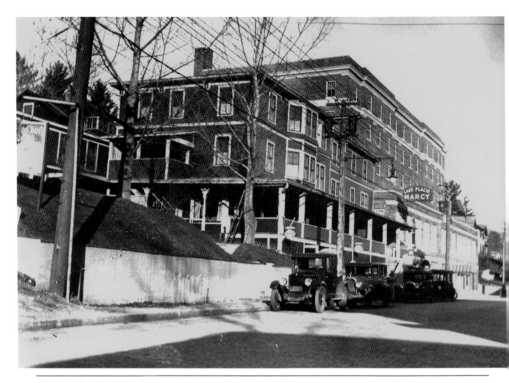

In 1897, Wes Kennedy built the Northwoods Inn on Main Street. Frank Swift bought it and in 1927 added a formidable addition and called it the Hotel Marcy. Swift lost the Hotel Marcy during the Depression. It has had several owners. In 1940, Jack Davis, a hotel man, signed a lease and later purchased it. He ran it successfully for 30 years. In 1970, it was sold, and again changed hands several times. It is now the Northwoods Inn.

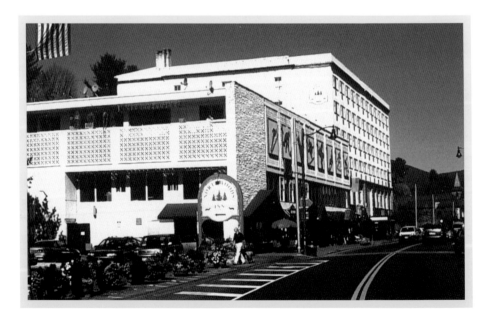

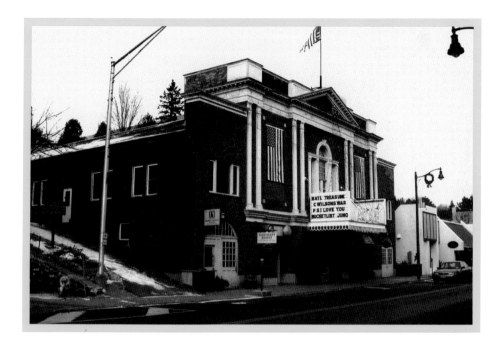

The Palace Theatre on Main Street was opened in May 1926 for silent films and later "talkies." It now has four theaters within its walls. The original Morton organ is still used for the annual Silent Film Festival. Since 1961, the theater has been owned and operated by the Reginald Clark family as the Adirondack Theatre Corporation. The Palace Theatre also has a store and apartments on each side of the entrance foyer.

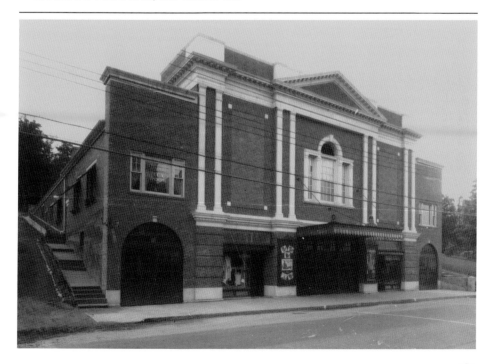

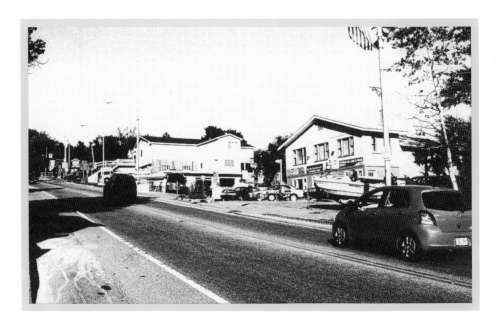

This photograph of Mill Hill, then Main Street and now Sentinel Road, was taken in 1925 when a highway crew was paving the road. The buildings on the right have been replaced over the years. The three-story apartment building was used then to house Lake Placid Club employees. Main Street turns left at the top of the hill, and Wilmington Road is on the right. The light-colored building in the contemporary image houses a used car and repair business.

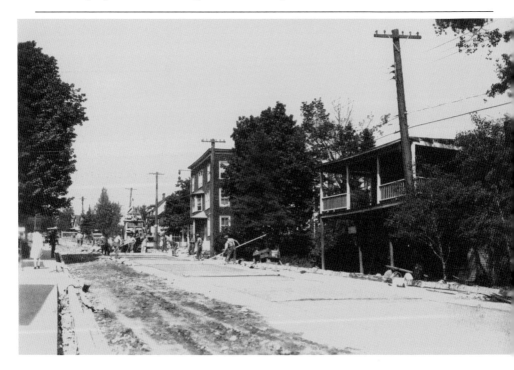

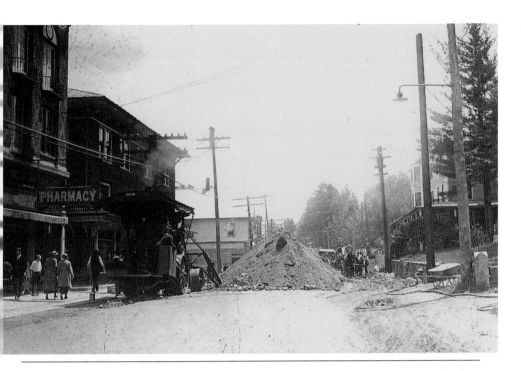

The paving of Main Street was a major undertaking by the village fathers in 1925. First dirt, then brick, it is receiving its first layer of macadam and a new water line. The building next to the pharmacy, on left, was Lake Placid's first silent movie theater, the Happy Hour. It closed when the Palace Theatre was built and "talkies" arrived. A third story was added and it has been known as the Wanda Apartments ever since.

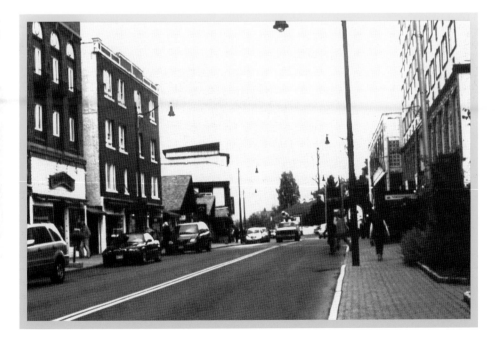

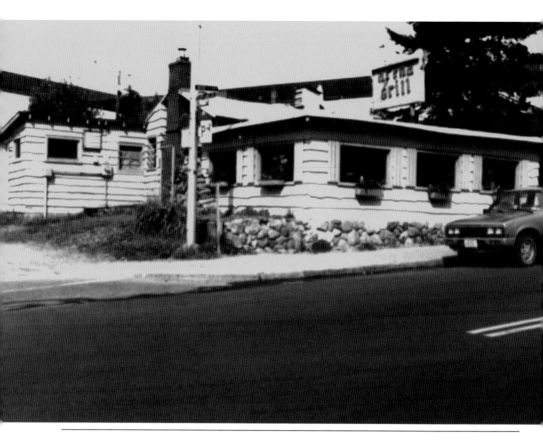

This Main Street building began its life as a small sports shop in the 1930s shortly after the Olympic Arena was constructed for the 1932 Winter Olympics. In the late 1930s, it was enlarged and became the Arena Grill, a popular meeting place and watering hole after skating shows and other arena events. It became a sports shop again in the 1990s. For the last four years, it has been a store known as There . . . and Back Again.

Cassius "Cash" Brewster opened this dairy on the corner of Wilmington Road and Main Street in the 1920s. He sold it to the Loren Torrance family in 1930, who operated the dairy until the 1960s, when it was sold to the Au Sable Dairy. The property exchanged hands again when it was purchased by the Schmitt Company, who razed the building and built a Sunoco gas station and convenience store, shown here. Sunoco recently purchased the property.

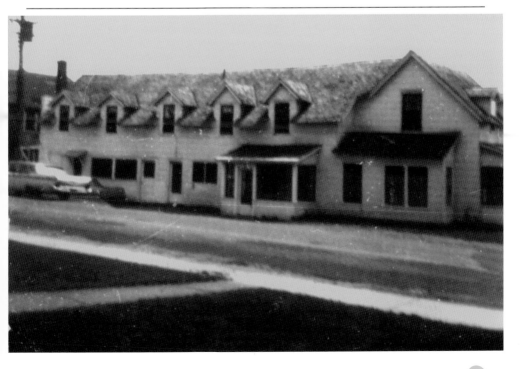

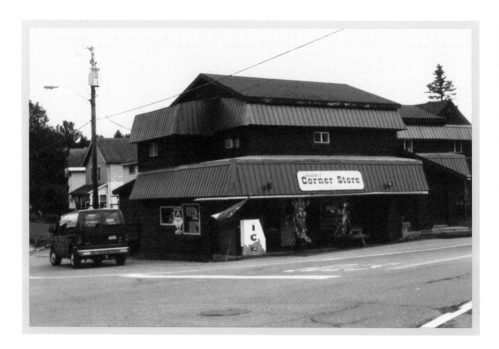

Located on the junction of Sentinel, Cascade (New York State Route 73), and Newman Roads, this small, corner grocery, or the Corner Store as it has been called over the years, is privately owned and has served the area residents since the 1920s. Gas is no longer sold there. The renovated building also has several apartments and office space in it. "Turn left at the Corner Store to go south" is popular directional advice given to visitors.

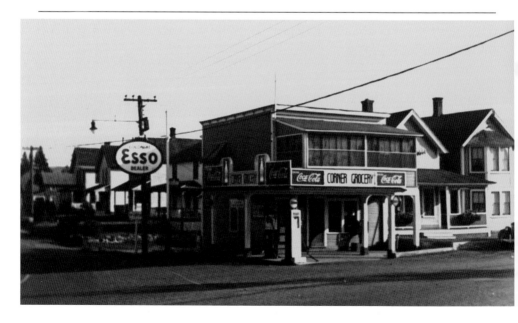

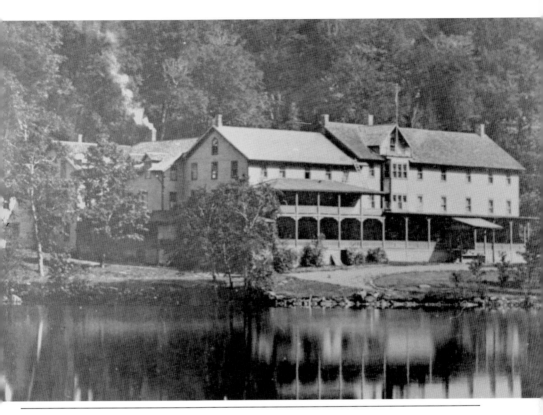

Cascade House, a small hotel popular with hikers and fishermen, was built between the Cascade lakes in 1878 after the road from Keene was cut through the pass between Pitchoff and Cascade Mountains south of Lake Placid. Later enlarged, it was run by the Lake Placid Club. It closed in 1929 after blasting while rebuilding the road, which was located above it, did extensive damage. It was later torn down. Today, state-owned, the property is used for picnicking, fishing, and boating.

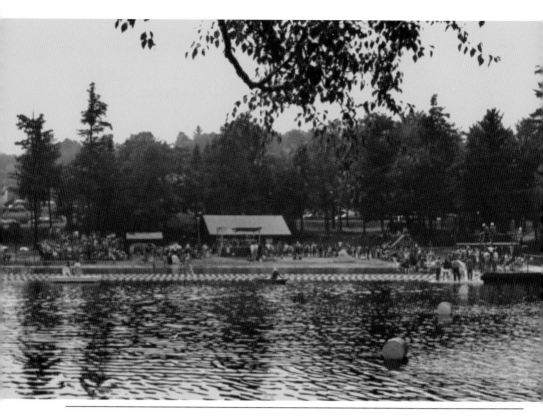

The village established a free public beach on Mirror Lake in the late 1930s. The annual AAU swimming competition was held there for many years. In the 1990s, the beach house was razed and replaced by the large one to serve the public and U.S. Canoe and Kayak Association, which is no longer there. The Lake Placid Ironman uses the beach for its swimming event. The Lake Placid Essex County Visitors Bureau is now occupying the second floor.

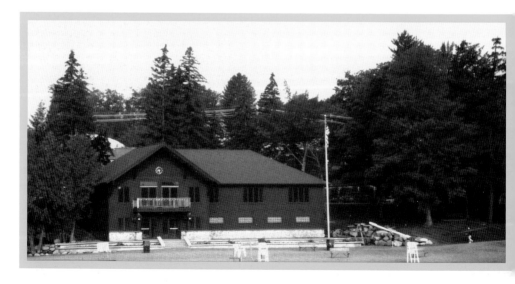

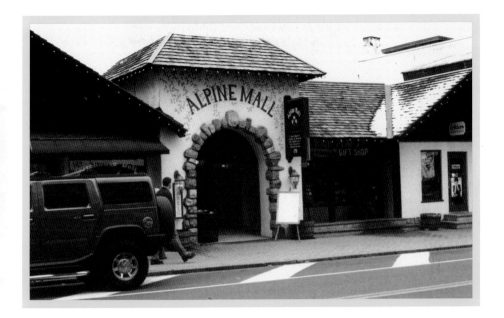

A private beach for Hotel Marcy guests was situated on Mirror Lake across Main Street from the hotel for some 30 years. Here the hotel's guests had a place to relax, swim, go boating, and enjoy refreshments. For strollers on Main Street, it was a popular place to stop and view the lake. In 1974, the property was sold. Hotel rooms facing the lake and the mini Alpine Mall, part of the adjacent Golden Arrow Hotel, now occupy the site.

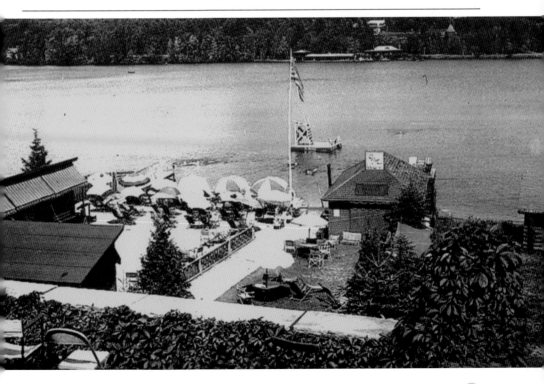

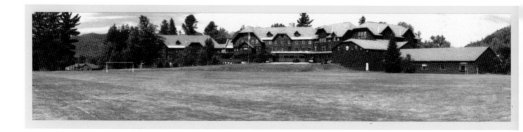

Northwood School began in 1905 as the Lake Placid School for Boys. It was housed at the Lake Placid Club in the fall and spring and moved to Florida for the winter. In 1927, a year round school was built on the Lake Placid Club's property and became the Northwood School for Boys. In the 1960s, the school became co-ed and a girl's dormitory, visible on far left, was added. Several additions have been made to both ends of the original building.

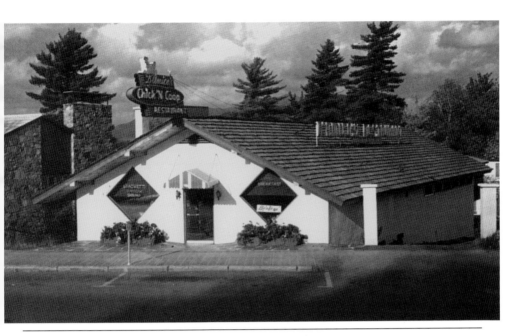

Olympic bobsledder Bill D'Amico built the Chick-N-Coop Restaurant on Main Street near the Lake Placid Post Office in the 1950s. It was across the street from the village parking lot. He sold it in the 1960s, and it changed hands several times. The Black Bear Restaurant was the last occupant. In 2003, the building was sold to the Golden Arrow Hotel, which razed it and constructed an addition to the hotel with stores at street level and hotel rooms above.

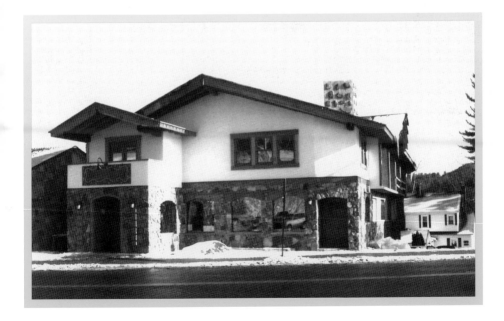

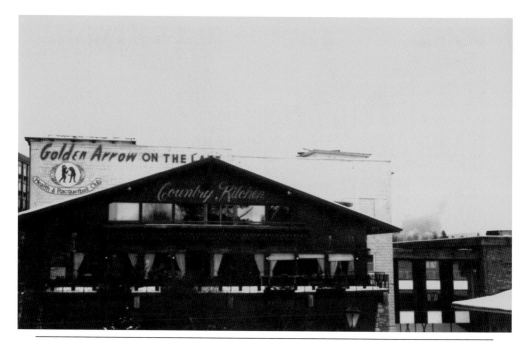

Isadore and Bessie Urfirer operated the Little Restaurant on Main Street for 40 years. In the 1970s, they purchased the adjacent Grandview Beach on Mirror Lake and erected a motel called the Golden Arrow and a restaurant by the same name, which replaced their Little Restaurant. It has had a variety of names since then. In 2006, it was completely renovated as Charlie's. The motel was sold in 1974 to the Winfred Holdereid family, who have enlarged and renovated it.

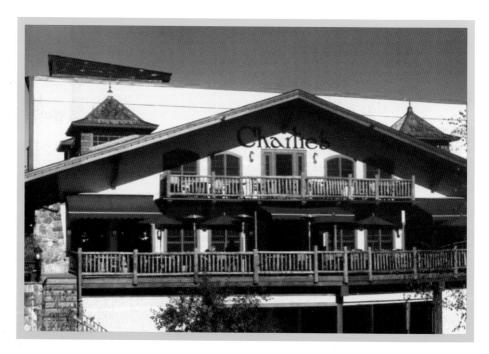

The contemporary photograph shows the Lake Placid News building on the left. In 1975, Ed and Bobbi Hale, the newspaper's owners, bought and refurbished the building giving the Lake Placid News a permanent home after 70 years. The original building dates back to the 1900s and was for many years a harness shop and then home to several restaurants. The *Lake Placid News*, a weekly newspaper, has served the community since 1905 and has had six owners during those years.

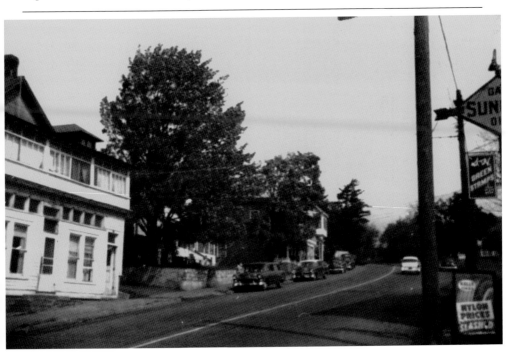

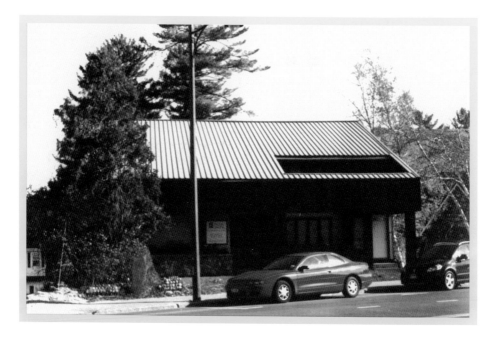

The James D'Amico family opened the second Northwoods Inn on Main Street in May 1933 after another inn by the same name had been annexed to and became the Hotel Marcy. Sold to Ruth English in May 1945, it burned on December 30, 1945, and was completely torn down in 1953. Several years later, a building housing apartments and offices for a real estate firm and attorney Favor Smith's law office was built on its foundation. The house on the left in the vintage image still exists.

CHAPTER 4

THE TWO OLYMPICS AND THE CHANGING SCENE

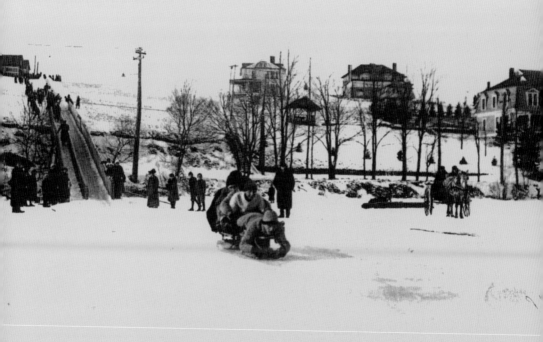

About 1895, a toboggan slide was built at the north end of Mirror Lake with a bridge built over the road. Both residents and visitors made the long climb up only to fly down on their toboggans or bobsleds at speeds over 60 miles an hour and often travel halfway across the lake. The building on the far right is the original Mirror Lake Inn building. A public toboggan slide is now located at the south end of Mirror Lake.

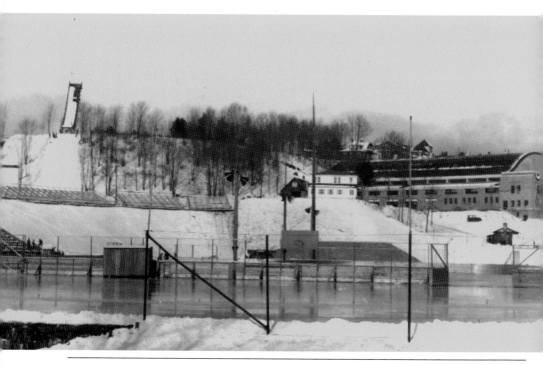

Taken from the south end of the speed skating oval in 1932, the historical photograph shows the small ski jump, which stood on the hillside since the 1920s and the Olympic Arena, built in 1931 for the Olympics' indoor ice events. The 1980 Olympic Center, in the contemporary photograph, was annexed to the Olympic Arena. It was the site of the United States' "Miracle on Ice" hockey victory. The speed skating oval in front of the high school was refrigerated in 1979.

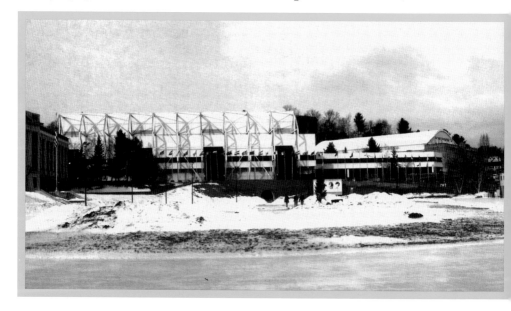

THE TWO OLYMPICS AND THE CHANGING SCENE

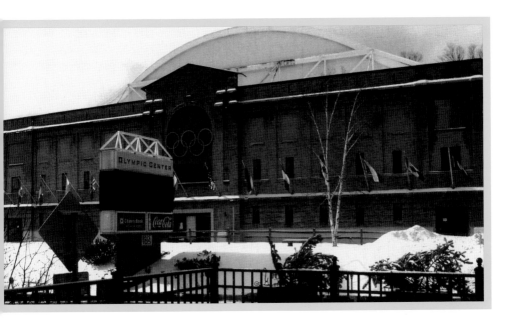

Built for the 1932 Winter Olympics, the Olympic Arena on Main Street provided the first indoor ice for Olympic figure skating and hockey events. The summer figure skating programs then brought the community world renown for some 50 years. In 1979, the Olympic Arena was refurbished for the 1980 Winter Olympics. Owned by the Town of North Elba, the arena is managed by the Olympic Regional Development Authority, which also manages all the Olympic sites including nearby Whiteface Mountain Ski Center.

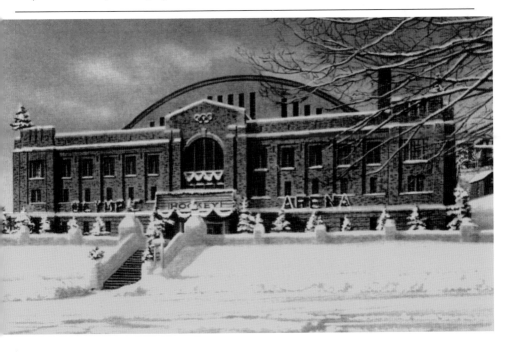

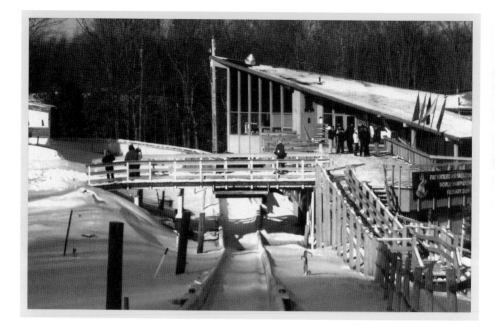

Bobsledding has been called "the champagne of thrills" since 1932. The finish curve viewing and timing buildings are shown behind these 1930s bobsledders. This bobsled run is no longer used in winter, but spectators can view the summer bobsled riders from the 1950s finish building as they ride in wheeled bobsleds from the half-mile. The new bobsled run is located above and also serves as a track for luge and skeleton competitors. Passenger rides are offered there during the winter.

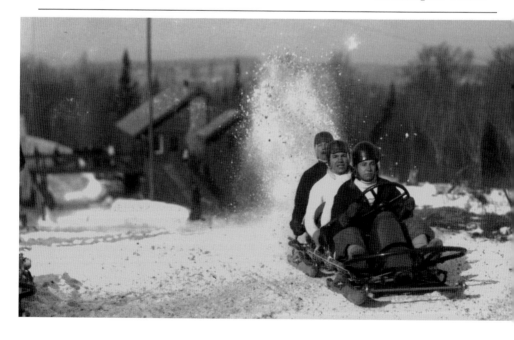

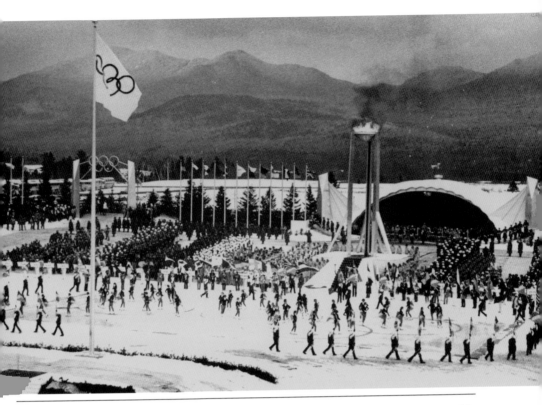

The opening ceremony of the XXIII Winter Olympiad was held on February 13, 1980, on the Lake Placid Horse Show Grounds. The lighting of the Olympic Torch was the ceremony's climatic event, as the numerous national teams stood by. The Olympic Torch still stands, refurbished and useable as a symbol of Lake Placid's devotion to sport and its continuous hosting of national and world-class events. It is lit for special occasions.

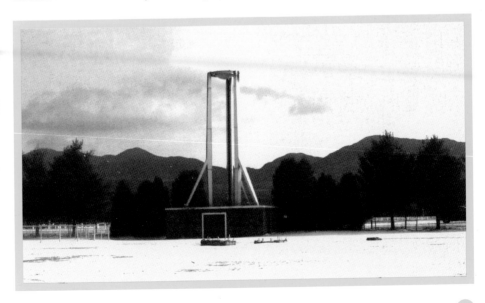

The Lake Placid Club built a 55-meter ski jump on its Intervales property on Cascade Road in 1920. As required, it was enlarged as a 70-meter jump for the 1932 Winter Olympics. It remained that size until 1978 when it was reconfigured into a modern 70-meter hill for the 1980 Winter Olympics and a 90-meter jump with a 26-story inrun tower with elevator was erected next to it. These town-owned jumps are now designated 90- and 120-meter hills.

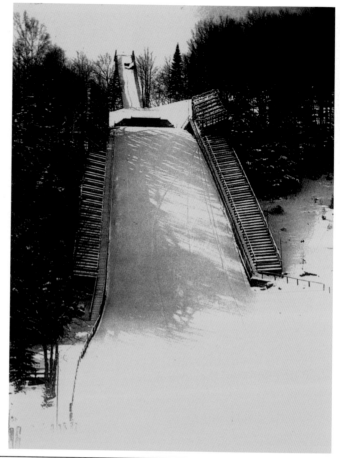

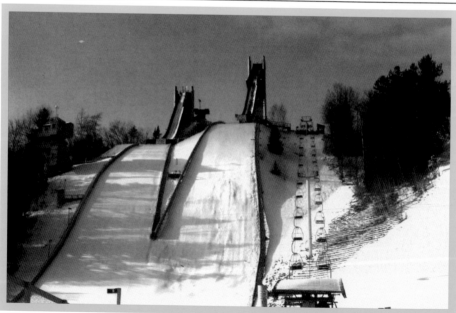

THE TWO OLYMPICS AND THE CHANGING SCENE

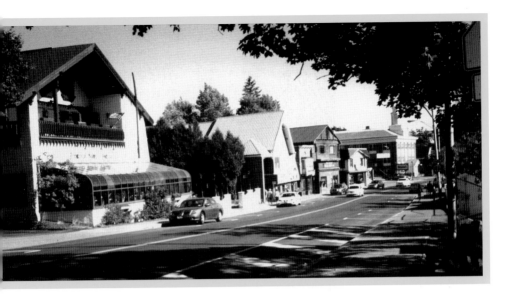

These photographs, taken in 1930s and 2008 show the buildings on the east side of Main Street that face the Olympic speed skating oval. The Fireside Steak House in the contemporary photograph stands where the Majestic Restaurant, visible behind the larger tree in the historical photograph, stood. The other buildings are the same but have had face-lifts over the years, including the town hall on the far right. The two buildings on the left were torn down.

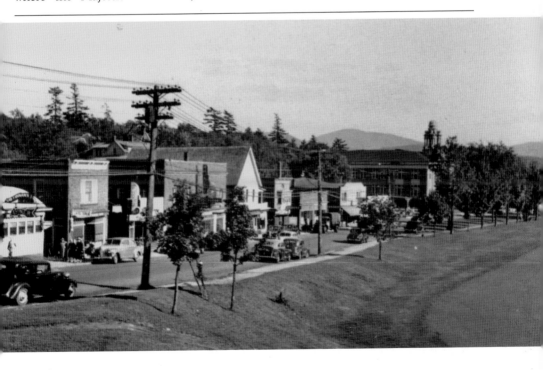

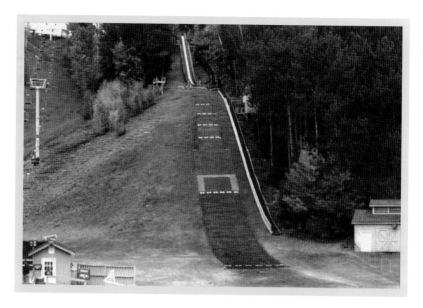

The 40-meter ski jump at Intervales, built about 1930, was a training hill during its early years. In 1947, jumpers organized the first July Fourth ski-jumping competition on it on ice cut from a nearby lake. The ice was stored and then crushed to jump on. A most successful event, it was held each year until the 1980 Winter Olympics. The redesigned jump now has a plastic surface, which makes it available for ski jumping the year round.

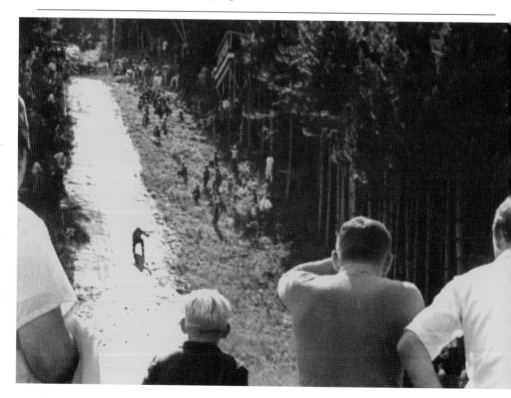

THE TWO OLYMPICS AND THE CHANGING SCENE

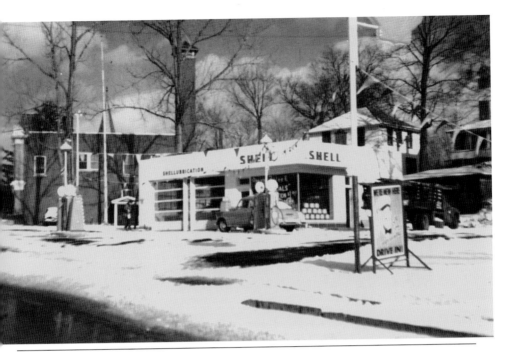

In 1952, Shell Oil Company built a service station on Main Street across from the Olympic Arena by removing a house owned by the Otis family. The station served the community for several decades. It was sold and renovated and over the years housed several restaurants. In 2000, the building was torn down and this large brick building replaced it. Two restaurants, Nicola's on Main and the 211 Grill, are located there.

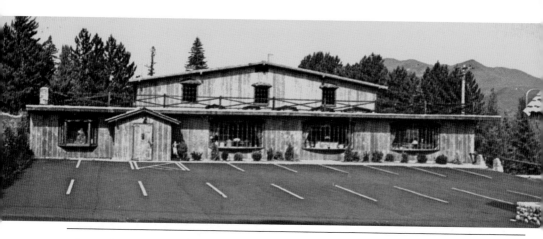

The Steak and Stinger Restaurant, opened on Cascade Road in 1963 by "Red" LaFountaine, soon became a favorite dining-out spot. He operated it for 27 years. The building was later occupied by Pizza Hut. In the late 1990s, a fire destroyed the building. The Marriott chain bought the vacant property in the early 2000s and built the 98-room Courtyard by Marriott hotel on it, which opened in February 2007.

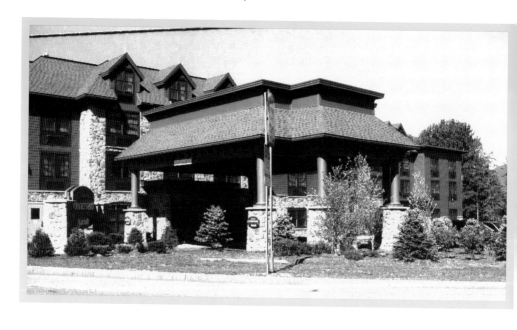

THE TWO OLYMPICS AND THE CHANGING SCENE

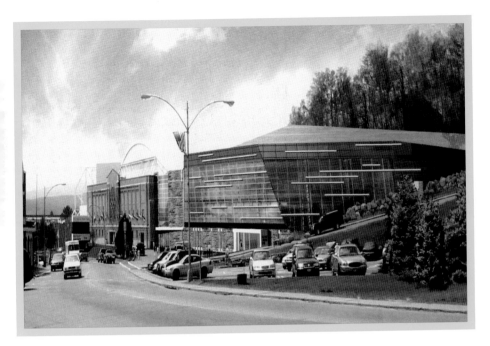

Lake Placid's Convention Center was built in 1968 at the north end of the Olympic Arena to provide meeting space adjacent to it for large groups. The building no longer met the technical and space needs of these groups. After it is razed, the new Conference Center will replace it, as shown in an architect's rendering in the above photograph, and address the needs of conference groups. The Conference Center is expected to open in the late summer of 2009.

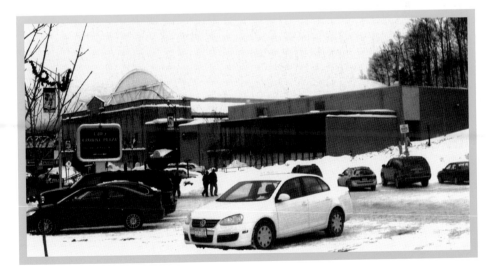

ACROSS AMERICA, PEOPLE ARE DISCOVERING SOMETHING WONDERFUL. *THEIR HERITAGE.*

Arcadia Publishing is the leading local history publisher in the United States. With more than 3,000 titles in print and hundreds of new titles released every year, Arcadia has extensive specialized experience chronicling the history of communities and celebrating America's hidden stories, bringing to life the people, places, and events from the past. To discover the history of other communities across the nation, please visit:

www.arcadiapublishing.com

Customized search tools allow you to find regional history books about the town where you grew up, the cities where your friends and family live, the town where your parents met, or even that retirement spot you've been dreaming about.